COPYING MASTERPIECES

José M. Parramón

Copyright © 1981 by Parramón Ediciones, S.A.

First published in 1990 in the United States by Watson-Guptill
Publications, a division of BPI Communications, Inc.,
1515 Broadway, New York, New York 10036.

Library of Congress Cataloging-in-Publication Data

Parramón, José María.
 [Cómo pintar un cuadro célebre. English]
 Copying masterpieces / José M. Parramón.
 p. cm.—(Watson-Guptill artists library)
 Translation of: Cómo pintar un cuadro célebre.
 ISBN: 0-8230-2458-X (paperback)
 1. Cézanne, Paul, 1839-1906. Blue vase—Copying. 2. Pissarro,
 Camille, 1830-1903. Entrance to the village of Voisins—Copying.
 3. Painting-Technique. 4. Cézanne, Paul, 1839-1906—Criticism
 and interpretation. 5. Pissarro, Camille, 1830-1903—Criticism and
 interpretation. I. Title. II. Series.
 NC1656.C6613 1990
 741.2'35—dc20 90-12616
 CIP

Distributed in the United Kingdom by Phaidon Press Ltd.,
Musterlin House, Jordan Hill Road, Oxford OX2 8DP.

Manufactured in Spain
Legal Deposit: B-28.587-90

1 2 3 4 5 6 7 8 9 / 94 93 92 91 90

COPYING
MASTERPIECES

1

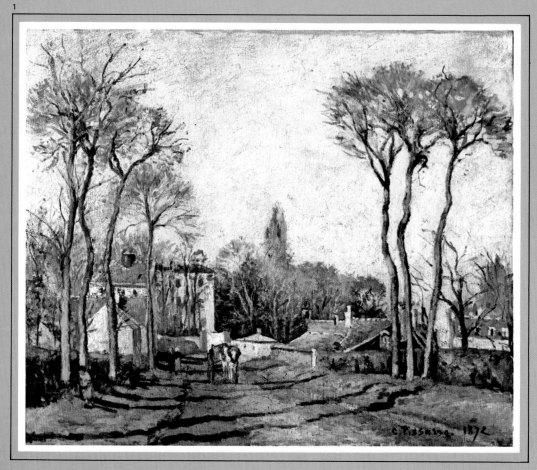

Fig. 1. *Entrance to the Village of Voisins*, Camille Pissarro (Orsay Museum, Paris).

Contents

2

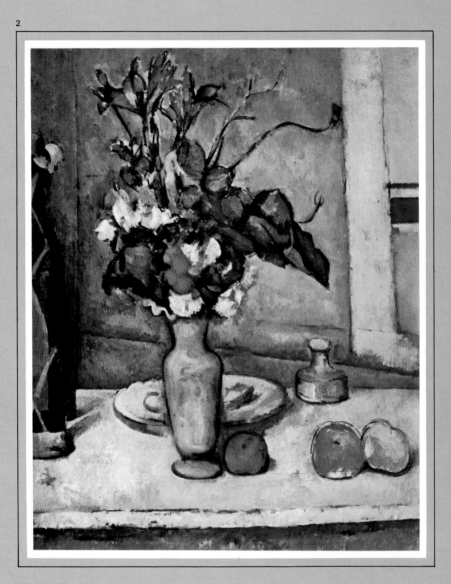

Fig. 2. *The Blue Vase*, Paul Cézanne (Orsay Museum, Paris).

Introduction

By reading this book you will learn how to paint copies of famous pictures. Why would you want to go to an art gallery or museum and set up an easel in front of a Monet, a Velázquez, or a Raphael? In museums the world over there are people who earn their living —a good living at that—by copying the works of famous painters. In Madrid I had the opportunity to meet professional painters whose copies sell for as much as one thousand dollars. And in just about every gallery and museum one comes across artists, both amateur and professional, who copy masterpieces in order to become better artists themselves. There is nothing new or strange about this. Raphael studied by copying the works of Leonardo da Vinci and Michelangelo. Rubens was fascinated by Caravaggio's dramatic use of light and shade, and copied his *Burial of Christ*. Degas was a frequent visitor at the Louvre. He copied the work of Velázquez, whom he greatly admired, and of Rembrandt, Giotto, Titian, Bellini, and, especially, Poussin. Manet had heard so much about Velázquez and Goya that he traveled to Spain, to Madrid's Prado Museum, for the sole purpose of acquainting himself with the way those artists handled figures and heads.

Indeed, copying masterpieces is an extraordinarily worthwhile exercise. I speak from experience. One day not long ago I went to the Prado Museum myself with the intention of painting St. Paul from Velázquez's *Saints Anthony Abbot and Paul the Hermit*. I went to the museum's office to ask permission and to fill out a form. They were very helpful, even lending me an easel so that I could paint more comfortably. Someone on the museum's staff told me that good copyists will do extensive research on an artist, his period and style, the picture in question, the materials used, and so on. I spent four wonderful mornings painting in one of the halls dedicated to Velázquez, the artist I wished to study. I felt exhilarated and taken back in time, as if Velázquez himself had been at my side, as if I were one of his pupils. I looked closely at his works, and I believe I learned a great deal about his use of flesh tones, those creams and pinks and grays. I grasped something about his use of foreshortening, that marvelous capacity to make forms look three-dimensional through contour alone. I immersed myself in the color, contrast, atmosphere, technique, and craft of this master of Spanish painting.

Introduction

When the picture was finished, I decided to share my experience with others. I felt that copying two pictures from the Impressionist period, a landscape and a still life, could be a splendid adventure and a fascinating lesson for many beginning painters. The paintings I chose were Pissarro's *Entrance to the Village of Voisins* and Cézanne's *The Blue Vase*. I thought that the copies could be done at home with the aid of true-color, large-scale reproductions. I studied and sought information about when and how these pictures were painted, who Camille Pissarro and Paul Cézanne really were, what materials they used, and how they worked.

Then I wrote this book.

José M. Parramón

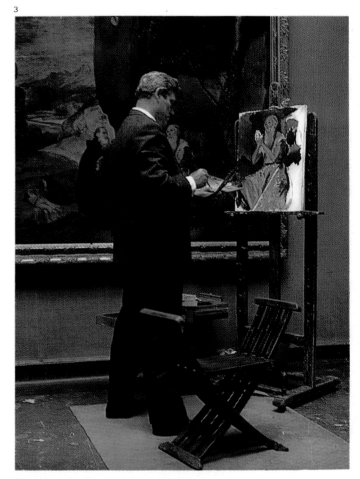

Fig. 3. The author, José M. Parramón, painting the figure of Saint Paul —from a detail of Velázquez's *Saints Anthony Abbot and Paul the Hermit*—at the Prado Museum, Madrid. The studio easel and seat were provided courtesy of the museum.

Fig. 4. A professional copyist at work on a reproduction of Velázquez's *Aesop* at the Prado Museum, Madrid.

Fig. 5. Detail of *The Blue Vase* by Cézanne (Orsay Museum, Paris).

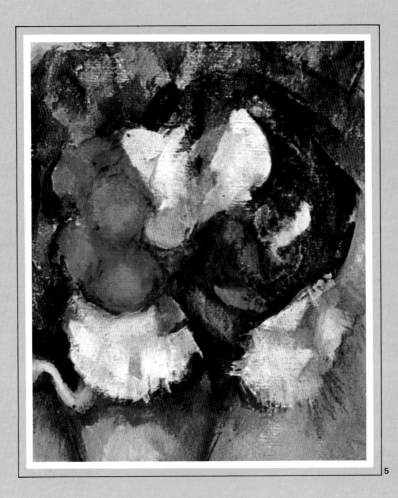

5

THE HISTORY
—OF—
IMPRESSIONISM

Impression: Sunrise

Our story begins in the home of George Nadar, a prominent Paris photographer, who lived at no. 31, Boulevard des Capucines. The date: April 15, 1874. Thirty painters gathered there to exhibit 160 pictures to both critics and the general public. The group lacked a name that would sum up its aesthetic aspirations and its place in the art world, opting instead for a curiously prosaic title: Limited Company of Painters, Sculptors, and Engravers.

Two days later, a review of the exhibition by the art critic Leroy appeared in a Paris newspaper. Writing of Claude Monet's picture *Impression: Sunrise*, Leroy stated flatly that no work of art could be created with mere fleeting impressions. Jeeringly, he called the artists dreamers and, in an ironic twist toward the end, *impressionists*. The name would bring fame. The group of painters known until that moment as "Manet's Bunch" would henceforth be categorized as *The Impressionists*.

This first attempt at a collective exhibition proved to be a resounding critical and financial failure. The few buyers whom the Impressionists had managed to attract, after years of hard struggle, drifted away, swayed no doubt by the unfavorable reaction of not only the critics but the public too. The French, having emerged just four years earlier from the disasters of war with the Prussians, were now riding a wave of conservative idealism; consequently, they were reluctant to accept change or revolution of any kind, be it social or intellectual. After all, Impressionism had already been rejected officially—in a word, doomed—by the Paris Salon (the only route to artistic recognition) a full ten

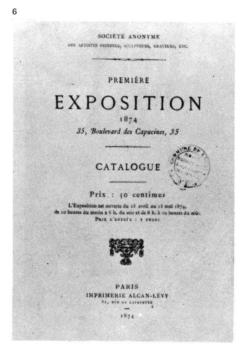

6

years before when the country was still at peace. Now it had become a matter of principle, of "peace and the public health," a conscious decision to bar the Impressionsts' way. A year after the ill-fated showing at Nadar's home, the Impressionists presented an exhibition at the Hôtel Drouot, but the protest reached such tumultuous proportions that the police had to intervene. The motley "Limited Company of Painters, Sculptors, and Engravers" went into liquidation, thus closing the door on an enterprise that had existed only in the mind of its creator, Camille Pissarro. The Impressionists' hardship began once again. In 1878, two of Pissarro's pictures would be publicly auctioned for 7 and 10 francs, respectively. Cézanne once qualified painting as "slave labor" —clearly with good reason.

7

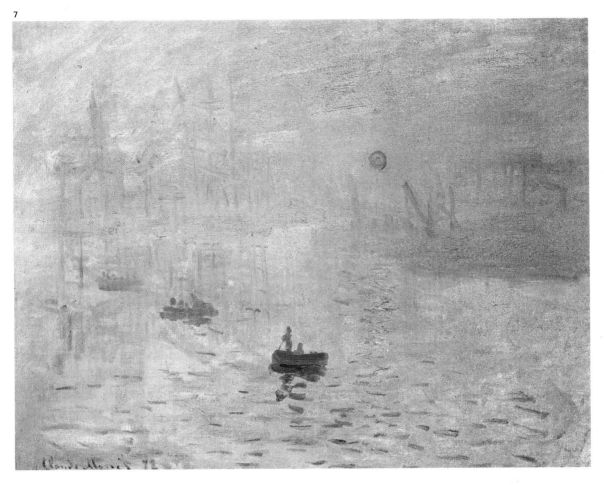

Fig. 7. This sunrise in the port of Le Havre, painted by Claude Monet and presented in the first exhibition of 1874 under the title *Impression: Sunrise*, (Marmottan Museum, Paris) prompted one art critic to speak of painters and *impressionists*, thus establishing the name of a new movement and a new style of painting.

The catalogue of the first exhibition held by the Impressionists in 1874, the cover of which is reproduced on the preceding page (Fig. 6), is interesting for a number of reasons. Apart from the unusual name adopted by the group—Limited Company of Painters, Sculptors, and Engravers—one reads with surprise that there was an entry fee of one franc. The catalogue was sold at half a franc and the exhibition hours were 10:00 A.M. to 6:00 P.M. and 8:00 P.M. to 10:00 P.M. Inside the catalogue, in alphabetical order, were the names of thirty artists and, under each name, the artist's address. Only one woman's name appears, that of Berthe Morisot. Immediately preceding her on the list was Claude Monet, one of whose pictures we see in the illustration above. The editing and printing of this first catalogue was supervised by Renoir's brother, Edmond, who only a few days before had asked Monet what title he had in mind for "that picture of the sun emerging from the haze," to which Monet responded, "Why don't we call it *Impression: Sunrise*?" Louis Leroy, a critic at the humor magazine *Charivari*, wanted to poke fun at that "bunch of crackpots." He concocted an article imagining the comments of one of the prize-winning Academy artists, who, upon visiting the exhibition, might have uttered: "Impression—he calls it impression. I too am impressed by this impression and this freedom and this ease of execution! Wallpaper is better finished than this painting!" Only a few days later, *Le Siècle*'s critic, Jules Castignary, also referred to the term *impressionism*. And so the new movement was defined. But the term was not to be officially adopted till the third exhibition was held in 1877.

Manet, Monet, Pissarro, Cézanne

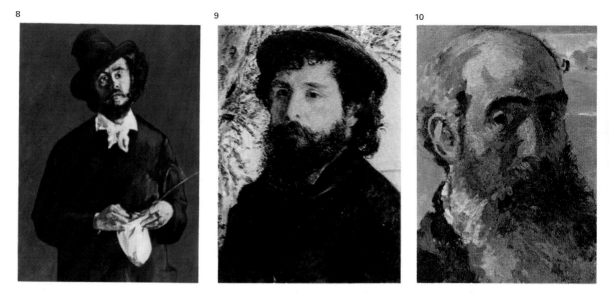

Fortunately for the world of art, there were two indomitable artists among the Impressionists, two real giants who were prepared to give their all in order to see the triumph of their ideas: Claude Monet and Camille Pissarro. These two men seized the initiative for the entire group. Monet, as a painter full of fighting spirit, dictated the rules while his marvelous work continued to reveal the potential inherent in the new style. Pissarro, more of a theoretician, an intellectual with progressive ideas, determined the doctrine of the new school.

There was also a third man: the equally renowned artist Edouard *Manet*, who must not be confused with the above-mentioned Claude *Monet*.

In 1863, nine years prior to the Nadar exhibition, Edouard Manet painted his celebrated pictures *Le Déjeuner sur l'herbe (Luncheon on the Grass)* and *Olympia*. It was, in fact, these two works and their conceptual break with the past, their subject matter, and the scandalous uproar accorded them by critic and public alike that laid the foundations of Impressionism.

Manet, however, lacked the faith and humanity of Monet. Paradoxically, the only similarity between the two men lay in their respective surnames. Manet was rich, Monet was poor. Manet suffered the enemies of Impressionsm, Monet re-

jected all compromise. The Legion of Honor was ultimately accorded to both men; Manet accepted the award, Monet rejected it. And it must be remembered that Edouard Manet did not figure among the artists who exhibited at Nadar's. He was not a revolutionary, nor did he wish to be one. Only a year before the Nadar showing he had been admitted to the Paris Salon, and he did not want to lose the ground he had gained. Exhibiting at the Salon of the French Academy meant having customers, selling pictures.

However, Monet and Pissarro were not alone. They were in splendid company at Nadar's with Boudin, Cézanne, Degas, Berthe Morisot, Renoir, Sisley, and Rouart.

What was it that united these artists? What was so remarkable about their work that we should consider them, together with the geniuses of the Renaissance, to be the most revolutionary artists of all time?

Fig. 8. *Self-Portrait with Palette*, Edouard Manet (Loeb Collection, New York).

Fig. 9. *Claude Monet*, Pierre Auguste Renoir (Orsay Museum, Paris).

Fig. 10. *Self-Portrait*, Camille Pissarro (Orsay Museum, Paris).

Fig. 11. *Self-Portrait with Beret*, Paul Cézanne (Boston Museum of Fine Arts).

Fig. 12. *Self-Portrait*, Edgar Degas (Orsay Museum, Paris).

Fig. 13. *Berthe Morisot with a Bunch of Violets*, Edouard Manet (private collection, Paris).

Fig. 14. *Self-Portrait*, Pierre-Auguste Renoir (Fogg Art Museum, Cambridge, Massachusetts. Maurice Wertheim Collection).

11
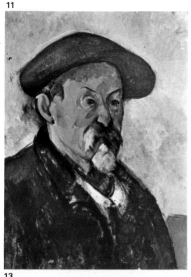

12
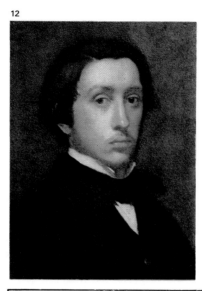

Between 1874 and 1886 the Impressionists held eight exhibitions. Outstanding among the participants in the first exhibition were Boudin, Cézanne, Degas, Guillaumin, Monet, Berthe Morisot, Pissarro, Renoir, Rouart, and Sisley. Pissarro participated in all of the exhibitions. Berthe Morisot and Rouart participated in all but one. Cézanne took part in only two, and Boudin only in the first one. Manet did not make an appearance at any of the exhibitions.

13
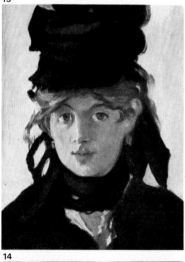

14
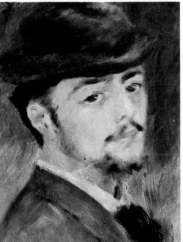

April, 1876. The Second Impressionist Exhibition. Reviewed by Albert Wolff in the newspaper *Le Figaro*.

"Five or six lunatics, including a woman, a group of wretches tainted by ambition's folly, have come together to exhibit their works. Some people may split their sides laughing at such things, but I have a heavy heart. These so-called artists say they are uncompromising, impressionists; they take paint, canvas and brushes, randomly throw out some color and hope for the best. In so doing, they remind one of the unfortunate folk at the Ville-Evrard mental asylum, who collect stones and imagine that they are diamonds. A dreadful spectacle of human vanity stretched to the point of insanity! would someone please make Mr. Pissarro understand that trees are never violet, that the sky is never the color of fresh butter, that the things which he paints are seen nowhere on earth, and that no one of any intelligence can accept such aberrations. But this is just a waste of time, like trying to convince one of Dr. Blanche's inmates—who thought he was the Pope—that he lived in Les Batignolles and not in the Vatican. Try to make Mr. Degas see the light. Tell him that in art there exists certain qualities which are called drawing, color, execution, intention. He will laugh in your face and treat you as reactionaries. Attempt to explain to Mr. Renoir that a woman's torso is not a heap of decomposing meat with greenish-violet stains like those of a cadaver in a state of advanced putrefaction. There is also a woman in the group, as in all the famous bands. Her name is Berthe Morisot and she's worth observing. She has as much feminine charm as the rantings and ravings of a delirious spirit."

Impressionism and its roots

The history of Impressionism is the history of light in pictures, of light colors upon canvas. It is also the history of painting in the open air. Impressionism probably began with some of the Old Masters, such as Titian, who, as early as 1500, painted atmospheric landscapes in the backgrounds of his pictures. Velázquez is sometimes called the first Impressionist because of his schematic use of shape and color and his ability to represent complex forms with a few brushstrokes. Then there is Goya, who could capture a fleeting gesture or expression in a few quick strokes. Of Velázquez, Léon-Paul Fargue has written, "There is the technique of Degas in his picture *Las Hilanderas (The Spinners)*. Velázquez was modern; he heralded the future, opening the doors to bold horizons. He discovered a path that was light, airy, and vibrant, which one day would be followed by Daumier, Corot, Manet, Renoir." It is a well-known fact that Edouard Manet, the pioneer of Impressionism, was wholehearted in his admiration for Velázquez and Goya. He drew inspiration from them.

Historical accuracy would be better served to say that Impressionism was born from "a desire for the truth," of which the artists Daumier, Millet, and Courbet were champions. Technically speaking, it began with Corot and Courbet; it was nourished by the influence of what came to be known as the Barbizon School; and the fray was joined by Manet. All of this took place between 1820 and 1860. This progression will be better understood if we go back in time to the years immediately following the French Revolution of 1789.

16
17

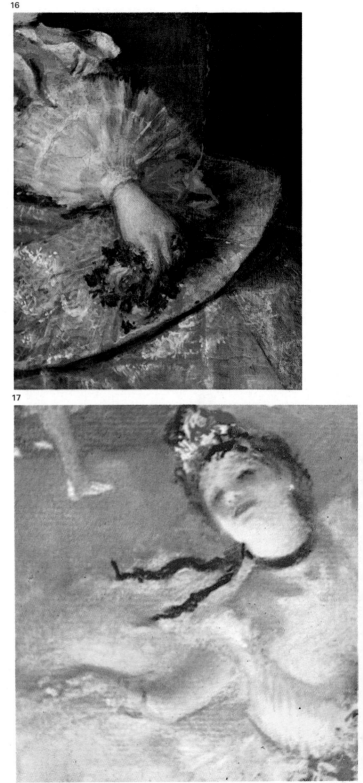

15

Fig. 15. *The Infanta Margarita* (right), Velázquez (Prado Museum, Madrid). This is an exceptional portrait in which nothing is over- or understated, in which everything is expressed perfectly.

Fig. 16. Detail of *The Infanta Margarita* (top, opposite page). Note Velázquez's extraordinary technique —his quick, suggestive rather than descriptive brushworks, a hallmark of Impressionism.

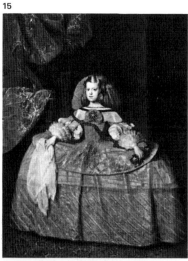

18

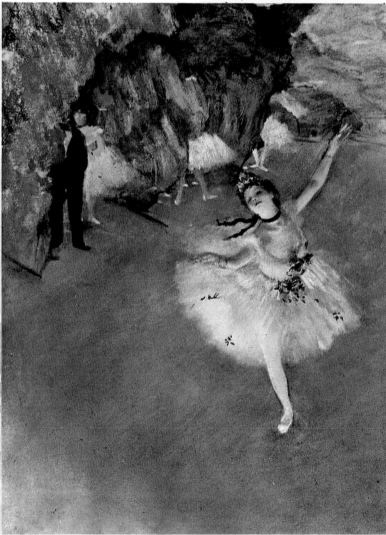

Looking at some of the pictures by Velázquez and Goya, it is easy to see why these two artists were called the forerunners of modern painting and, more specifically, of Impressionism. Look, for example, at the Infanta Margarita's hand (Fig. 16, p. 14) holding the rose. Observe the sparse brushstrokes with which the artist rendered that hand, and note the almost abstract patches of color making up the rose. The overall effect is of something that is not definitive but that suggests, rather, a fleeting *impression*. Notice also the hand, face, and flowers in *Dancer at the Footlights* (Fig. 17). It is worth mentioning that Manet visited the Prado Museum in Madrid with the express purpose of studying the techniques of Velázquez and Goya to understand their way of fusing shape and color.

Fig. 17. Detail of *Dancer at the Footlights* (bottom, opposite page) by Degas. The effect of the arm and the hand, of the face and the crown of flowers recalls Velázquez in the confidence and freedom of execution.

Fig. 18. *Dancer at the Footlights*, Degas (Orsay Museum, Paris). Note the similarity to Velázquez in the loose, seemingly abstract rendering of detail —an approach that always requires an absolute mastery of drawing.

Romanticism

Following the French Revolution in 1789, the art world found itself in the full flood of Romanticism. "The artist," wrote Novalis, "must romanticize the world. He must invest the commonplace with nobility, the everyday with the dignity of the unknown, and the temporary with an aura of timelessness." And the artist readily complied with the tastes of the period, painting vast historical compositions, pictures representing scenes from world literature, Oriental themes, and full-blown military displays glorifying hero, homeland, and victory. The most representative painters of this period were David and Gros, succeeded in time by Géricault, Delacroix, and Ingres.

This conception of Romanticism, the fact that scenes were represented that had nothing to do with the reality of daily life, thereby distorting the truth, clashed head-on with the social currents of freedom of expression and the search for truth advocated by the French Revolution. Opposing this grandiose role for art was a small group of painters who fought for naturalness and realism, most notably Daumier, Millet, and Courbet. These were painters of everyday scenes, of peasants and of townspeople.

Fig. 19. *The Raft of the Medusa*, Théodore Géricault (Louvre Museum, Paris).
19

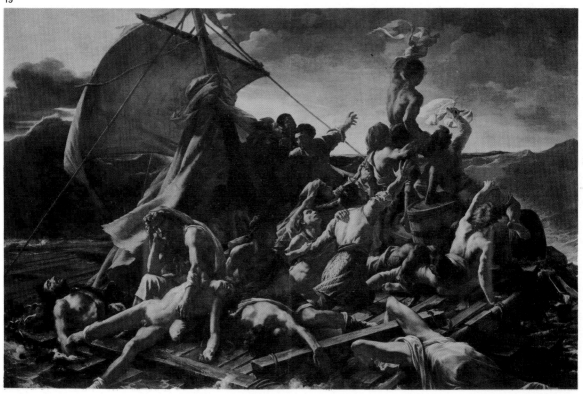

20

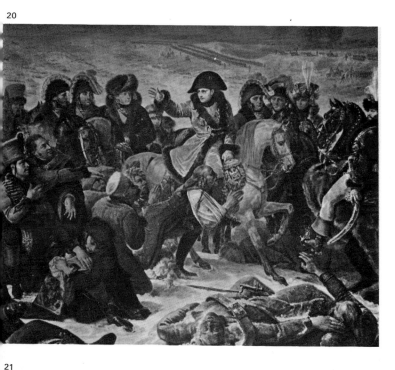

21

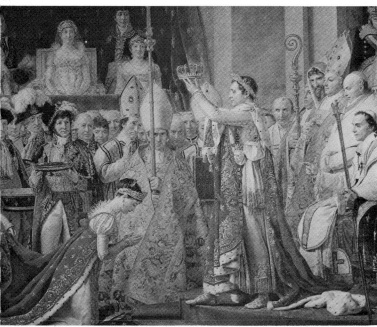

When the frigate *Medusa* sank in 1816, 149 people were left to die one after another on a raft without provisions. Only fifteen survived. Such was the subject of Géricault's *Raft of the Medusa*. It was a grandiloquent theme suited to its immense physical size: The picture is almost 16½ ft. (5 m) high and 23 ft. (7 m) wide. Look also at Antoine-Jean Gros's *Napoleon at Eylau* (Fig. 20), the dimensions of which exceed even those of *The Raft of the Medusa*. The Gros painting is 17½ ft. (5.33 m) high and 26 ft. (8 m) wide. Observe in both pictures the theatrical stance and gestures of the figures, which are in keeping with the 18th-century German poet Novalis's theories on Romantic art being the exaltation of human grandeur.

Finally, there is the gigantic picture painted by Jacques-Louis David between 1805 and 1807 entitled *Napoleon Crowning the Empress Josephine.* The grandiloquence of the subject, together with the monumental size of the painting —20 ft. (6.10 m) high and 30 ft. (9.31 m) wide— frankly surpass the limits of the imaginable.

Fig. 20. *Napoleon on the Battlefield at Eylau*, Antoine-Jean Gros (Louvre Museum, Paris).

Fig. 21. Detail, *Napoleon Crowning the Empress Josephine*, Jacques-Louis David (Louvre Museum, Paris).

Forerunners

Daumier, Millet, and Courbet, largely misunderstood, were accused of being superficial men without ideals. Nevertheless, their cry for the truth, for the genuine and the humane, was heard and imitated by young artists, first by the Realists and later by their heirs, the Impressionists. By the middle of the nineteenth century Courbet and his pupils Pissarro, Monet, and Renoir had succeeded in eclipsing Romanticism.

Another pupil of Courbet, a subscriber to Romanticism who also had a sincere desire for progress, was the renowned landscape artist Jean-Baptiste Camille Corot. This man, a fervent lover of Nature, was —without even being aware of doing so— pointing the way for the Impressionists. Corot was the first to speak of *painting impressions.* "One must never lose the first *impression* produced by a landscape," he said. Corot obeyed this rule, respecting and abiding by Nature.

He painted the initial impression and rejected the Romantic notion of landscape with all its conformity to idealistic shapes and colors. The difference between landscapes of the Romantics and those of Corot was the contradiction between true and untrue, between fact and fiction. In general, until Corot appeared, the landscape had never been painted outdoors. The Romantics—like the Old Masters before them—would make some preliminary sketches outside, drawing and constructing perfectly (with pencil, charcoal, sanguine, and so on) the shapes of trees, stones, banks, and borders, but then would paint their landscapes in the studio using the sketches only as reference material. With knowledge of such painting methods, it becomes much easier to understand the tendency of Romantic artists to idealize, transform, romanticize, and, in a word, misrepresent their subject matter.

22

The artist Gustave Courbet was a friend of Pierre-Joseph Proudhon, a French socialist and political writer whose book *On the Principles of Art and Its Social Function* emerged as a result of listening to Courbet's polemics. In these pages Proudhon defended the motifs that Courbet, Millet, and Daumier were painting at that time in contrast to the historical subjects of the Romantics, and of Géricault, Gros, and David: "One must paint men in the truthfulness of their nature and habits, at their jobs, fulfilling their civic and domestic functions, with their true features and, above all, with no artificial poses; surprise them, so to speak, with their consciences stripped bare, not just for the pleasure of ridiculing them but also with a didactic purpose in mind, as if it were a lesson in aesthetics."

Jean-François Millet, in complete harmony with this idea, spoke of the golden meadows and the sublime spectacle of the sun, basking in the glory of its own light. "But this," adds Millet, "does not mean that I fail to see the horses ploughing on the smoky plain and, in a rocky place, a man behind the plough, stooped and exhausted, trying to straighten his back to take a breath and shouting all day, 'Come on, come on!'" Honoré Daumier was another chronicler of the age. He was a republican and a revolutionary, an illustrator, caricaturist, and painter who, in his drawings, poked fun at the pomp and affectation of the Romantic movement, and in his paintings showed, without compromise or melodrama, the tribulations of humble people, of plain, everyday folk.

Fig. 22. Photograph of Courbet (Sirot Collection, Paris).

Fig. 23. *The Winnowers* (detail), Gustave Courbet (Nantes Museum).

Fig. 24. *The Laundress*, Honoré Daumier (Orsay Museum, Paris).

Fig. 25. *The Washer-woman* (detail), Jean-François Millet (Orsay Museum, Paris).

The plein-air movement

The Romantic artist sought exaltation, communion with God, through painting a landscape that would reveal the true state of his soul. The soul's mood might be happy or sad, dynamic or melancholy, passionate or indifferent—it made little difference, as long as the painting was a true reflection of that condition. The faithful recording of the landscape itself, of reality, was not an issue. In opposing this way of seeing and doing things, Jean-Baptiste Camille Corot, perhaps unconsciously, raised the banner of the *open-air school*. *Pleinairism* was a word the artists and critics of the time had adopted in order to differentiate between landscape painters who worked in the studio and those who went directly to Nature herself.

It is interesting to observe that this formula of painting studio landscapes—without the model at hand—had become so entrenched that even such artists as Corot did not dare to put the finishing touches on a painting in the open air. Even after pleinairism had been accepted, Corot would continue to repaint and retouch works in his studio. As he admitted to Renoir when the latter became his pupil, in the country one could never be sure of what one was doing. It was always necessary, he felt, to have a final look at the painting in the studio.

In passing, let's make it clear that the members of the plein-air movement advocated a number of specific tenets: painting in the open air; capturing the genuine impression the landscape produced on the artist; and rendering *motifs* instead of *subjects*. The Impressionists, as followers of the pleinairists, adopted all of that group's rules as their own, with particular emphasis on the last one. It was believed that old-fashioned artists painted *subjects,* which is to say they prepared their compositions down to the last detail as if staging a play, with the figures dressed and placed according to the most suitable color, gesture, and position. The modern painters intended to paint *motifs,* that is, things

that were alive, spontaneous, naïve, natural. In short, they wanted to paint slices of real life. This idea as a hard-and-fast rule was no doubt far-fetched, but we must remember that these modern painters thought that extreme measures were called for to combat the Romantics, whose principal artistic thought centered around grand historical, military, religious, mythological, or literary subjects, all of which were designed to portray a false world of unreal images.

Fig. 26. *Recollections of Pierrefonds*, Jean-Baptiste Camille Corot (Pushkin Museum, Moscow)

27

28

Fig. 27. *Orpheus and Eurydice*, Nicolas Poussin (Louvre Museum, Paris). A classic example of a picture whose theme and composition have been worked out in advance.

Fig. 28. *The Pavers of Rue de Berne*, Edouard Manet (Collection of Lord Butler). An example of the picture-*motif*, painted with no previous preparation.

The Barbizon School

The plein-air movement, advocating a new way of observing landscapes, came into being in and around the village of Barbizon in the Forest of Fontainebleau, where the artists found countless motifs and impressions to be captured on canvas. The community of ideas and the style of those gathered there burgeoned into the Barbizon School, of which Jean-François Millet and Théodore Rousseau were to become the leading exponents. Corot would also go to paint with the Barbizon group, although far less frequently, given his understandable feeling that it was hardly necessary to travel to Fontainebleau just to paint good landscapes.

The Barbizon School's ideas were shared and put into practice by several foreign artists, including Germans, Belgians, and Englishmen. Notable among the English painters were Turner and Constable, who were themselves ground-breakers in the open-air landscape painting movement.

In 1856, Gustave Courbet forged an important link with the plein-air movement in his painting *Demoiselles des bords de la Seine (Young Girls on the Banks of the Seine)*. Here Courbet mixed techniques by painting the landscape directly from nature, then working on the figures later in the studio.

Fig. 29. *In the Forest* (pencil drawing), Corot (Louvre Museum, Paris).

29

At the beginning of the nineteenth century, the Forest of Fontainebleau was a favorite haunt of young Parisian landscape painters. With such beautiful spots as the Chailly plain, the Bois-Bréau clearings, the lovely view at Franchard, and the Apremont valley, Fontainebleau was the meeting place for those young artists who believed in open-air painting, of pinning down nature's real image. Of the numerous artists who painted there before 1840, the most outstanding was Corot. Later, in the 1804s, Théodore Rousseau and Jean-François Millet painted their most famous pictures there. This rendezvous at Fontainebleau lasted several years until the artists finally fixed their meeting place at an inn in the small town of Barbizon. Night after night, the artists who painted at Fontainebleau would gather at La Mère Ganne, a tavern in Barbizon. There they would ridicule the Salon pictures—or the "big brutes," as the enormous historical canvases had come to be known—and defend realism, the fresh and spontaneous treatment of landscapes executed *en plein air* at Fontainebleau. It was at these gatherings that the Barbizon School came into existence.

In Paris, meanwhile, Monet had tired of his daily routine in the studio of his teacher, Marc Charles Gabriel Gleyre, where he chatted with Sisley, Renoir, and Bazille, and sketched from live models. Finally he said to his friends, "Let's get away; we're stagnating. Nothing is real here—let's go and see the Barbizon group!" Díaz, Daubigny, and Courbet were there, too.

30

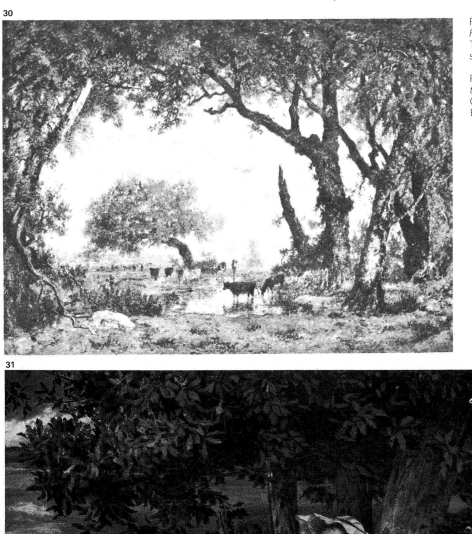

Fig. 30. *Leaving the Forest of Fontainebleau*, Théodore Rousseau (Orsay Museum, Paris).

Fig. 31. *Young Girls on the Banks of the Seine*, Courbet (Musée des Beaux-Arts, Paris).

31

Realism

In 1862, something altogether commonplace occurred that would have an impact on the theories and techniques of Impressionism. Reproductions of Japanese prints appeared in the shop of a certain Mme. Soye in Paris.

The young artists were to discover in these prints two factors unknown to Western painting: forms rendered as flat, evenly colored shapes rather than as objects or planes modeled in light and shadow to give the illusion of three dimensions; and a new method of composition, in which figures were cropped as required by the demands of the picture, resulting in much greater freedom and realism than had been previously acceptable.

Then in 1863, Edouard Manet painted his famous *Déjeuner sur l'herbe (Luncheon on the Grass)*. Two new factors appeared here that, together with those described by the pleinairists, would constitute the basis of Impressionism: the tendency toward painting with lighter colors, and the elimination of contrasts and strong shadows to suggest volume. Influenced by Japanese art, Manet painted *Olympia*, in which these factors were consolidated, signaling the introduction of a new school: *Realism*.

Manet suffered the consequences of painting in this new way: *Déjeuner sur l'herbe* was rejected for exhibition by the Paris Salon. The jury not only determined the picture to be the work of an amateur who did not know how to suggest volume, but condemned it as "indecent." Considering that the Louvre's galleries abounded with nudes, such an assessment was unreasonable. What really happened was that the old jury simply could not accept the message inherent in the picture: that a new era had begun. Given that as long ago as the Renaissance artists had been accustomed to representing volume through the interplay of light and shadow, it is surprising to see how Manet was able to achieve in his figures not only shape by the way he placed flat, or nearly flat, colors next to each other, but also the illusion of

Fig. 32. *Le Déjeuner sur l'herbe*, Manet (Orsay Museum, Paris).

32

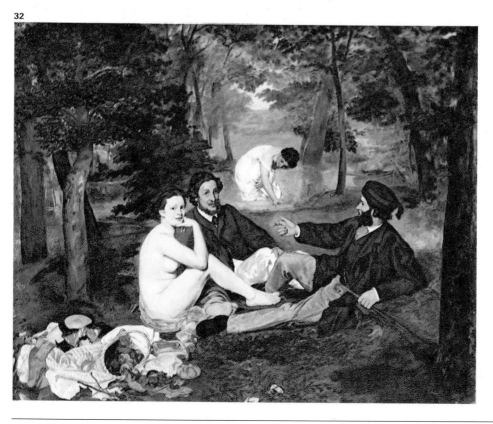

33

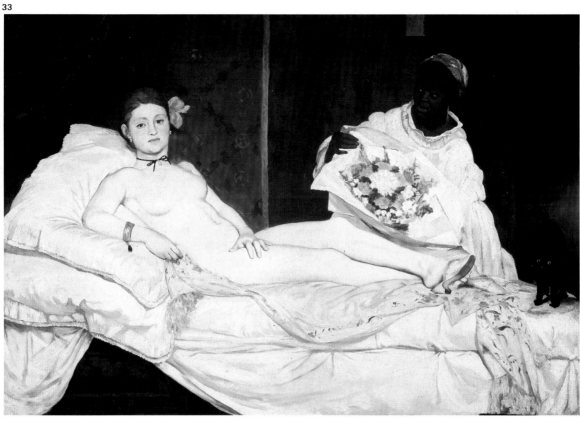

hree dimensions—and all through color
alone, with hardly any tonal shading.
The best demonstration of this skill can
be seen in *Le Fifre (The Fifer)*. The un-
precedented realization of volume in this
picture would later exert a great in-
fluence over Degas, Toulouse-Lautrec,
Gauguin, and even Matisse.

34

Fig. 33. *Olympia*, Manet
(Orsay Museum, Paris).

Fig. 34. *The Fifer*, Manet
(Orsay Museum, Paris).

The birth of Impressionism: recipes for a revolution

The struggle began. Encouraged by Courbet and Corot, the young artists, who one day would be famous, formed a group. With the boundless enthusiasm of youth, they managed to obtain permission from the Government to open an unofficial salon in Paris. This exhibition would be called *Le Salon des Refusés (Salon of the Rejected)*. However, the fruition of modern painting—portraying the atmosphere and the luminous color of the sun, painting with the colors of light—had yet to be reached. And artists still went home to the studio to put the finishing touches on their paintings.

One day around 1870 the young painters set off for the sea, to the northern beaches of Sainte-Adresse, Le Havre, and Dieppe. Until then, no one had ever painted the sea in light colors, or seen it as a motif unto itself; it had always been incorporated as an element in dramatic, grandiose subjects. It was there in the north that Monet, Sisley, Bazille, and Jongkind "discovered" light. It was there that they became aware of light permeating everything, vibrating, *moving,* of color itself as light. Light and color were what really determined the shape of any object. They understood that local color could be found only in the mid-tones, that inherent in the color of a shadow is its complementary color, that blue is always found in the color of shadows, and that colors enhance and illuminate one another when they are juxtaposed in specific combinations. Thus was Impressionism born.

At this time, the most representative group of Impressionists included the following artists: Boudin, the eldest at age 46; Pissarro, age 40; Manet, 38; Degas, 36; Cézanne, 31; Sisley, 31; Monet, 30; Renoir, 29; and Bazille (who was to die that same year), 29. They were followed by Jongkind, 51; Fantin-Latour, 34; Odilon Redon, 30; Berthe Morisot, 29; and Guillaumin, 29.

The most famous heirs and successors to their artistic movement had already been born: Gauguin, who in 1870 was 22; the legendary van Gogh, who was 17; Seurat, the creator of *pointillism*, 11; and Toulouse-Lautrec, who at that time was only 6.

Among these artists there were those who had no financial difficulty whatsoever. Manet, Degas, Bazille, and perhaps one or two others were all from well-to-do families who provided them with unlimited support. Then there were those who could paint and live in moderate comfort, coming as they did from middle-class families who sent them allowances or periodic financial assistance: Such were the circumstances of Boudin, Sisley, and Cézanne. And then there were Monet, Pissarro, and Renoir, the penniless ones, who experienced genuine hardship in order to continue painting. Renoir was remarkable for his brave and optimistic temperament; he was always in a good mood, laughing even at his own hunger. Pissarro, an upright and idealistic man and the father of seven children, experienced hunger and abject poverty. Monet, on the other hand, was unsociable, passionate, a born fighter who lived only for his art. Misunderstood by a father who demanded he choose between returning home or "living like a bohemian," Monet reached such desperate depths that one day he attempted suicide, as he revealed in a letter to Bazille, his friend and protector in times of greatest need.

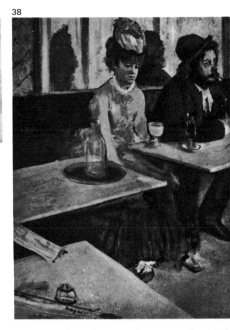

Figs. 35-37. Small-scale reproductions of *Déjeuner sur l'herbe*, *Olympia*, and *The Fifer*.

Fig. 38. *L'Absinthe*, Degas (Orsay Museum, Paris).

Déjeuner sur l'herbe, Olympia, and *The Fifer* were probably the key works in establishing a new ethos and a radically significant change in the art of painting. *Déjeuner sur l'herbe* was painted by Manet in 1863 and presented at the Paris Salon that same year. It was turned down. The total number of works rejected that year included some 2,000 pictures and a thousand-odd sculptures. It was a scandal. The indignant artists protested and Emperor Napoleon, in an effort to placate them, ordered a special exhibition independent of the official one, to show the rejected works. The picture that attracted the most attention at this second exhibition, provoking laughter and derision of the worst kind, was *Déjeuner sur l'herbe*. The Salon des Refusés was unique, this being its first and only incarnation. In 1865 Manet submitted *Olympia* to the Salon. The jury accepted his work this time, but in general the public and critics considered the picture to be in bad taste, without artistic value, and the work of a beginner.

In 1866, Manet painted *Le Fifre (The Fifer)*. That same year he presented it to the Salon, which rejected it. *The Fifer* is authoritative in its exposition. The background, an undifferentiated gray-ochre, indicates neither floor nor wall, and in fact is flat; yet in spite of this, it is undoubtedly a background, meaning it is *behind the figure*. There is a flat black in the tunic, shoes, and cap. In the red trousers, creases are merely suggested with nearly imperceptible brushstrokes; the red is a full, flat hue when one looks from a distance or through half-closed eyes. The boy's face is almost without light or shadow. Manet's handling of his subject marked a radical departure from the prevailing artistic notion that light plus shadow equals depth. *The Fifer* also strongly echoes Japanese-style prints, garments, and décor that abounded in Paris at that time. The Japanese painted in flat colors, but they also cropped their images with much greater freedom that Western artists did. Manet, Monet, Pissarro, Degas, and all the rest appreciated the artistic possibilities inherent in this new way of framing images, placing them off-center or close to a margin, using even the margin itself as a means of cropping. (See the framing of Degas's *L'Absinthe* (Fig. 38), with its cut-off image of the man.)

Subsequently, not only Manet but the rest of the Impressionists as well painted *motifs* instead of *subjects*. When these artists went to paint by the sea, they lightened their palettes even more. So Impressionism firmly established itself through the use of bright colors, more imaginative borders and compositions, slice-of-life motifs, and open-air impressions painted in broad daylight. Study the reproductions on pages 28 and 29 as examples of typically Impressionist formulas.

The birth of Impressionism: recipes for a revolution

39

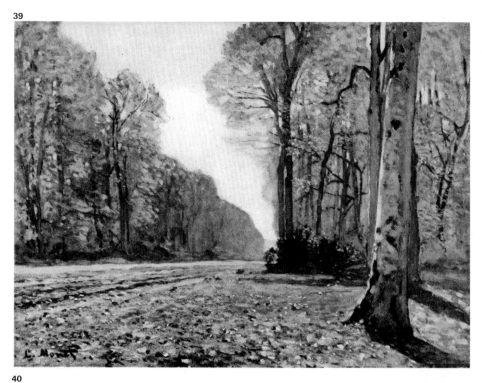

Fig. 39. *The Bas-Bréau Road*, Claude Monet (Orsay Museum, Paris). This is one of the first pictures painted by Monet in the Forest of Fontainebleau.

Fig. 40. *The Seine at Marly*, Pissarro (private collection). Painted in 1871, with a typically lighter palette.

Fig. 41. *Racehorses before the Stands*, Degas (Orsay Museum, Paris). Notice the unusual way Degas has cropped the picture.

Fig. 42. *Smoker Leaning on His Elbow*, Cézanne (Hermitage Museum, Leningrad). An example of *motif* painting.

40

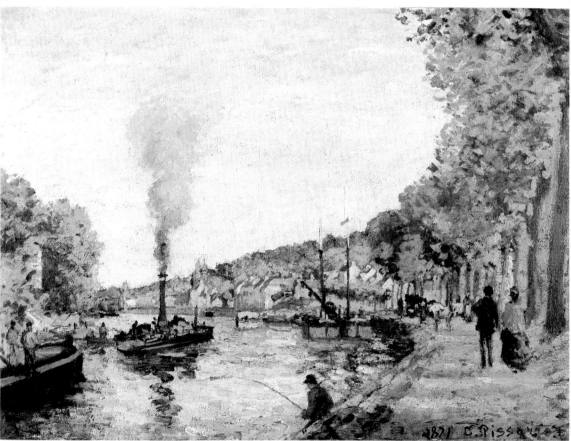

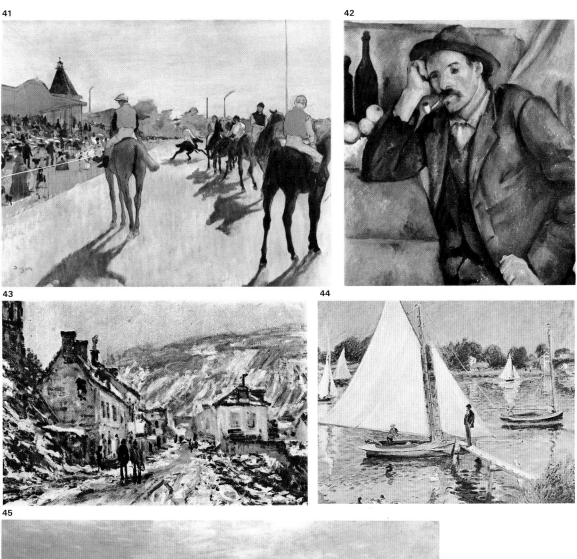

41

42

43

44

45

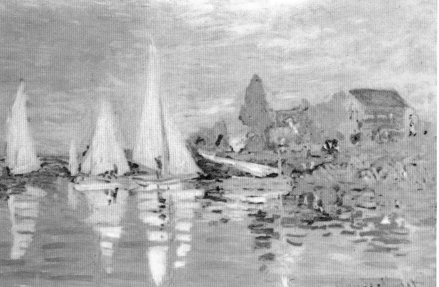

Fig. 43. *The Road to the Village*, Monet (Museum of Art Göteborg, Sweden). Another good example of a *motif*.

Fig. 44. *The Seine at Argenteuil*, Renoir (Portland Art Gallery, Portland, Oregon). The Impressionists went to the sea for the express purpose of painting *motifs* in light colors.

Fig. 45. *Regatta at Argenteuil*, Monet (Orsay Museum, Paris).

The Impressionists: tragedy and triumph

It may be said that until the year 1860 the Impressionists did not sell a single picture. Until then they were regarded as amateurs with advanced ideas, not worthy of being taken seriously. Yet the controversy that their work provoked succeeded in drawing the attention of art collectors. Sales were stimulated by the commotion caused by Manet's *Déjeuner sur l'herbe.* The exhibition of *Olympia,* however, resulted in another setback. From 1863 to 1870, the less prosperous of the Impressionists— Monet, Pissarro, and Renoir—barely managed to scrape out a living. In a letter to his friend Bazille, Monet wrote the following: "For eight days my wife, my son, and I have lived thanks to the bread which Renoir has shared with us. But as of today there is no more bread, no more wine, and no fire in the kitchen. It's terrible!" Renoir confirms this, also in a letter to Bazille: "I can't work because I've got no paints. I can almost always be found at Monet's house, who, by the way, is looking older. We don't eat every day."

The year 1870 brought the Franco-Prussian War, breaking up the group that had met regularly at the Café Guerbois. Manet and Degas enlisted in the National Guard. Cézanne fled to Marseille. Monet and Pissarro escaped independently to London, where they would later be reunited. Pissarro's departure was so hasty that when he left his home and studio in Louveciennes, he could take no more than a few of his own paintings and some of Monet's that he kept in trust. The majority of the canvases Pissarro had painted since 1855 had to be left behind. Prussian soldiers set up a butcher shop in his house. Pissarro's and Monet's pictures were used as door mats, spread out in the garden for the men to clean their boots on.

Not everything was a disaster. In London, Monet and Pissarro met the famous art dealer Durand-Ruel. Appreciating the artistic value of the canvases, Durand-Ruel began paying the painters 200 to 300 francs per picture. Back in Paris, he increased payment to 400, and eventually to 3,000 francs per picture. The Impressionists' work, then, was fetching good prices. It appeared that hunger and poverty had finally been overcome. At a sale in 1873 held at the Hôtel Drouot (a place renowned for its art auctions), paintings by Degas were priced at 1,100 francs. Sisley's work sold for 400 to 500 francs. A landscape by Pissarro reached 950 francs. The Monets fetched around 1,000 francs. En-

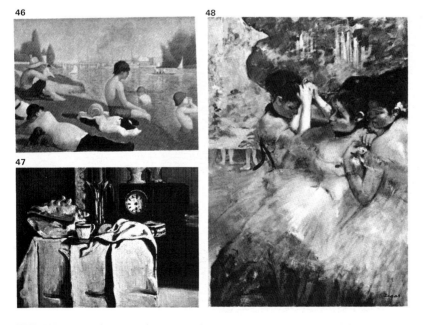

46

48

47

Fig. 46. *Bathing at Asnières*, Georges Seurat (National Gallery, London).

Fig. 47. *The Black Clock*, Cézanne (Edward G. Robinson Collection, Beverly Hills, California).

Fig. 48. *Dancers Preparing for the Ballet*, Degas (Chicago Art Institute).

Fig. 49. *The Cradle*, Berthe Morisot (Orsay Museum, Paris).

Fig. 50. *St.-Lazare Station*, Monet (Hon. Christopher MacLaren Collection, England).

couraged by this kind of response, the group decided to hold a collective exhibition in the home of Nadar, the photographer, in 1874. We are familiar with the results.

Later, when the public, critics, and art dealers alike turned their backs on them, the Impressionists once again traveled the road of misfortune. There were moments during those 16 years from 1874 to 1890 in which life for these men, especially Monet and Pissarro, was materially unbearable. When Monet's wife died in 1879, he had to look desperately for someone to loan him a few francs so he could redeem a medallion from the pawn shop. "It's the only trinket that my wife managed to save," he wrote, "and I would like to fasten it around her neck before she departs forever." In 1878 the old fighter Pissarro seemed ready to give up: "I can't take it anymore," he wrote to his friend Murer. "I can't paint, or if I do I paint without joy and enthusiasm, thinking that in the end I'll have to abandon art and look for another trade, that is, if I can learn one. It's sad!"

And so it went until the beginning of 1890, by which time the Paris Salon had recognized the artistic merits of Impressionism and everyone "painted in light colors." The Impressionists had finally triumphed late in life, only a few years before many of them were to die. By sad paradox, the young artists of the period—among them Seurat, Gauguin, and van Gogh—were at that time advancing a revolutionary style of painting that earned the name *Fauvism*. The advocates of Fauvism claimed that Impressionism was already an obsolete school, approved by the Salon and accepted by juries incapable of understanding the new art of the twentieth century.

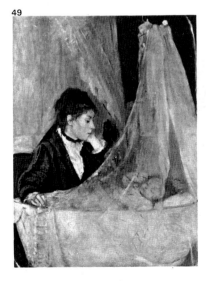

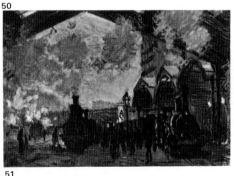

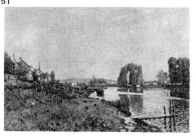

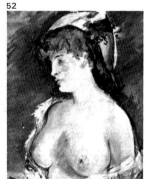

Fig. 51. *Ile St.-Denis*, Sisley (Orsay Museum, Paris).

Fig. 52. *Blonde Woman with Naked Breasts*, Manet (Orsay Museum, Paris).

53

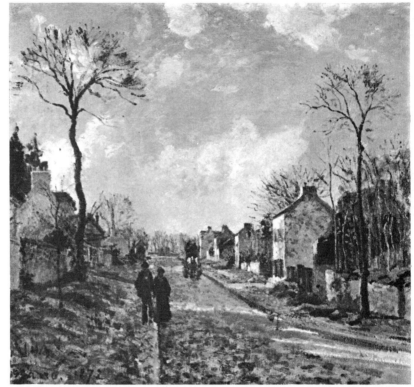

54

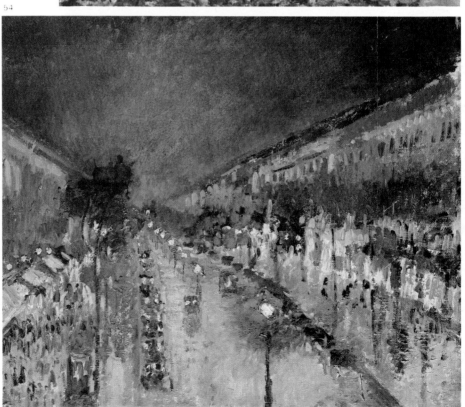

Fig. 53. *The Road to Lou veciennes*, Pissarro (Orsay Museum, Paris).

Fig. 54. *Boulevard Montmartre at Night*, Pissarro (National Gallery, London). The artist painted this picture from the window of the Hôtel Rusó.

Fig. 55. (opposite page): *Self-Portrait*, pen and ink, Pissarro (S.P. Avery Collection, New York Public Library).

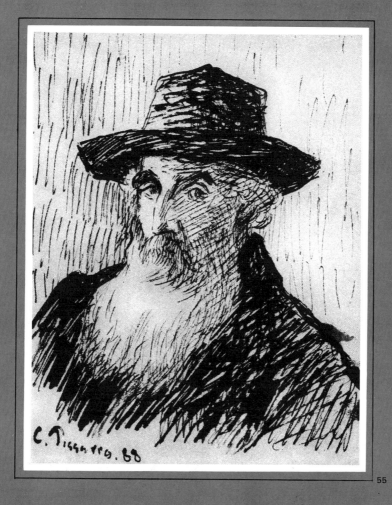

55

WHO
—WAS—
PISSARRO?

Pissarro, Corot's pupil

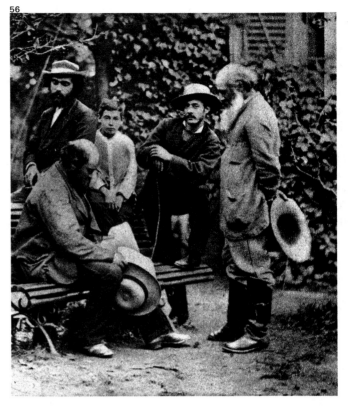

By the age of 47, Camille Pissarro had a very patriarchal look: almost totally bald, with weather-beaten skin, an ingenuous expression, and a long gray beard. He was tall, corpulent, round-shouldered, always looking people straight in the eye, shy, sincere, genuine, calm yet rebellious. As Cézanne was to say, he was "humble yet larger than life." With that beard, tanned skin, and his dark suit, Pissarro really resembled a prophet—so much so that one afternoon when he entered the Café de la Nouvelle-Athènes, the Impressionist group's Paris haunt in the Place Pigalle, with a portfolio under his arm, Renoir was prompted to call out, "Here he is! Moses with the Ten Commandments!" He had no enemies. He never envied the success of others, He was everyone's leader, judge, and counselor. He was also a teacher to many. One day Cézanne humbly sat down with him to copy one of his pictures. Cézanne was the elder artist's disciple, along with such other artists as Gauguin and Matisse. "Perhaps all of us descend from Pissarro," admitted Cézanne. The majority of Pissarro's biographers agree that he was a man of advanced ideas—a trade unionist, a socialist, and even an anarchist. There is no doubt that group action interested him (it had been his idea to create the Limited Company of Painters, Sculptors, and Engravers).

Let us imagine this man in the year 1855, arriving in Paris at the age of 25; before then very little is known about Pissarro, other than a few basic facts. Born on July 10, 1830, on the island of St. Thomas, one of the former Danish West Indies, he was the son of a French settler. He was sent at an early age to a school near Paris, and returned to St. Thomas when he was twenty. He soon ran away to Venezuela, moving about Caracas and living the life of a bohemian until he returned to Paris in 1855.

Thus our story begins with the arrival of young Camille and his visit that same day to the Paris World Fair (Exposition Universelle). At the Fair Pissarro ad-mired the works of Ingres, Delacroix, Rousseau, and Courbet, but finally found himself lingering over seven landscapes by Jean-Baptiste Camille Corot. He stopped, surprised to recognize himself in those pictures, to see in them a reflection, or rather a hint, of what his own painting style would eventually be. His pronounced shyness and the fact that he did not know any of the famous artists in Paris proved no barrier to his seeking out Corot directly at his studio and addressing him thus:

Fig. 56. Photograph taken in 1877 in Pissarro's garden at Pontoise. Pissarro, standing, is speaking to Cézanne. The boy in the center is Pissarro's son Lucien.

"I've come because I want you to show me how to paint like you."

Corot, then nearly 60 years old, offered Pissarro this advice: "Always strive for good drawing, good construction, and good volume."

Five years after his first visit, Pissarro was still painting exactly like a second Corot. His faith in his master, and his admiration for him, was such that until 1860 he would sign his pictures *Pissarro, Corot's pupil.*

"Be careful!" warned the critic Castignary. "Corot is a great artist, but you have to be yourself."

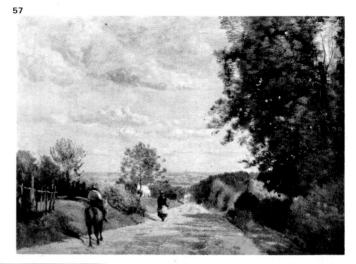

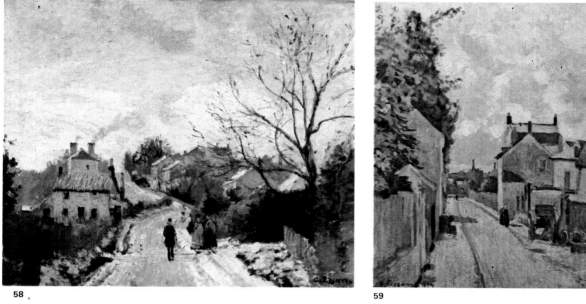

Camille Pissarro's admiration for his first master, Jean-Baptiste Camille Corot, determined to a certain extent not only his use of color but also his choice and composition of motif. In order to give a three-dimensional quality or depth to his landscapes, Corot showed preference for what was called *composition in perspective,* the choice of a motif and viewpoint in which a road or pathway would fade into the distance, where seemingly parallel lines would converge, lending a sense of three dimensions. Pissarro, following his master's example, painted the road motif many times, making a street disappear into the background of the picture. Monet, and, occasionally, Pissarro resolved this problem of depth by overlapping successive planes.

Fig. 57. *The Road to Sèvres,* Corot (Orsay Museum, Paris).

Fig. 58. *Snow at Lower Norwood,* Pissarro (National Gallery, London).

Fig. 59. *Rue à l'Hermitage, Pontoise,* Pissarro (Mrs. Franklin D. Roosevelt, Jr., Collection, New York).

The indefatigable artist

In 1866, Pissarro broke away from Corot, leaving Paris for Pontoise, a little village close to Paris but at a considerable psychological distance from Corot's studio. Here he painted in the open, while at the same time Cézanne was painting in the meadows of Provençal, Monet at Sainte-Adresse, Renoir and Sisley in the forest of Fontainebleau. These were the beginnings of the plein-air movement and of Impressionism.

Pissarro had been married for about eight years at that point, and five of his seven children had already been born. All of his children wanted to be artists too, thus further complicating their father's financial prospects. However, only Lucien, the eldest, was to fulfill his ambition to become a professional painter.

Pissarro remained in Pontoise only three years, moving in 1869 to Louveciennes, another town on the outskirts of Paris. At the outbreak of the Franco-Prussian War in 1870 he was forced to leave, choosing to go to London, where his mother lived. There he was to meet the dealer Durand-Ruel, a great patron of all the Impressionists. In London, Pissarro joined forces with Monet, a fellow war refugee. The two of them painted in England for more than a year. They visited the National Gallery and absorbed the work of Constable and Turner. Pissarro's time in London, and his exposure to the lighter, clearer colors of the English painters, caused him to wage a decisive personal battle against grays and pale siennas, struggling to eliminate them from his palette.

Until he died in 1903, Pissarro was never to stay long in any one place. He wandered throughout France, setting up his easel here and there. He returned to London, and from time to time went back to Paris.

He was present at the nine exhibitions that, in spite of all obstacles, the Impressionist group managed to organize, the last being mounted by Durand-Ruel. Indeed, it was this dealer who opened Pissarro's first independent exhibition in 1863. In 1885, Pissarro met Seurat and Signac, two young artists who had absorbed the theories of Impressionism and who were now trying to paint by treating color analytically. Attracted by this new movement, known as Pointillism, Pissarro adopted the style for a time, creating paintings that in 1886 were exhibited jointly with works by Seurat and Signac. In 1890 he abandoned this new method, returning to his former style. He always worked diligently. At the age of 70, Pissarro still went on excursions, traveling to Dieppe, Moret, and Rouen to paint ports, quays, bridges, and barges. He would visit these places in the spring and fall, taking advantage of the winter in Paris to paint scenes from the windows of his studio, a hotel, or the house of a friend.

Two months before his death at the age of 73, Pissarro could still be found painting throughout the summer at Le Havre. On November 13, 1903, he died, at peace with the world and remembering perhaps what he himself had written in one of his last letters: "It is incredible what I have had to endure, but if I had to do it all over again I would not think twice."

Fig. 61. *Snow at Louveciennes*, Pissarro (Folkwang Museum, Essen, West Germany).

Fig. 60. *In the Forest* (charcoal and white pastel on gray paper), Pissarro (Hyde Collection, New York).

Fig. 62. *Orchard with Flowering Fruit Trees, Springtime, Pontoise*, Pissarro (Orsay Museum, Paris).

60

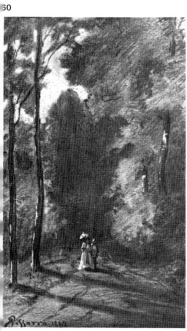

61

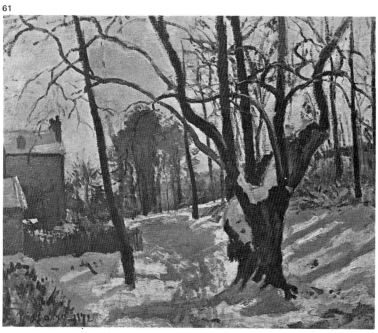

62

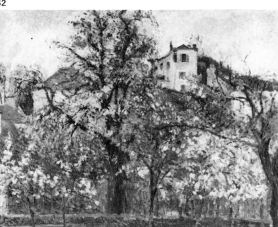

63

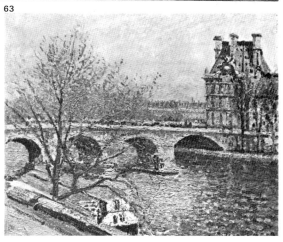

64

65

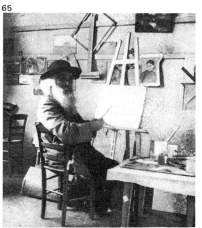

Fig. 63. *The Pont Royal and the Pavillon de Flore, Paris*, Pissarro (Petit Palais Museum, Paris).

Figs. 64 and 65. Left, a view of Pissarro's studio at Eragny; right, Pissarro painting in the studio in 1897.

At the end of this book you will find a folded color reproduction of Camille Pissarro's *Entrée de Village (Entrance to the Village of Voisins)*. This will serve as your model for painting a copy of this picture in oil.

Choose a comfortable and quiet spot in your home, and place this reproduction in front of you, fastening it with thumbtacks to the wall. Then set up your easel, chair, and worktable, more or less as you see it here in figure 66. Now, pretend that you're at the Orsay Museum in Paris. You're in front of Pissarro's original *Entrée de Village* and ready to begin painting a copy of this famous picture.

Before you start, let's consider the procedures you will need to observe when copying works in a museum collection.

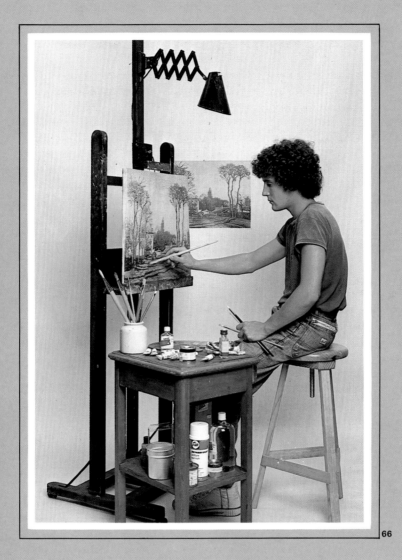

66

—COPYING—
MASTERPIECES

Painting at the museum

It's possible that one day you'll actually go to the Louvre or Orsay in Paris, the Prado in Madrid, or any other gallery in the world with the intention of copying a picture. Here, then, are some requirements to bear in mind:

1. Once you have chosen the picture, and studied the life and times of the painter in question—just as we have done—you should decide what size the copy will be. It may be bigger or smaller but for legal reasons never exactly the same size as the original. As a study exercise, you can also copy just a detail of the picture but you must still work in perfect proportion to the original.

2. In order to copy your chosen picture, you must request permission from the museum. You won't have any trouble obtaining authorization, provided you carry out certain prerequisites and observe the rules established by the gallery management. The majority of world museums and galleries will even provide you with an easel (upon request) to facilitate your work.

3. You should obtain the exact measurements of the picture you have in mind from the gallery archives, and also note the surface—canvas, cardboard, wood—as well as the materials used by the original artist.

4. At the same time that you reserve working space in the museum or art gallery, you should obtain a photographic or printed reproduction of the picture you've chosen so that you can do a line drawing or construction at home. Galleries all over the world generally have photographic archives from which you can obtain prints. It is customary to ask for a standard 8 × 10 in. (18 × 24 cm) black-and-white print. You can also work from a color or other black-and-white reproduction, or even from a postcard, any of which are likely to be available at the gallery or museum shop. Let's be clear, though, that a postcard will not suffice if you are making a very large copy.

5. Working at home, you should make a grid on the photographic or printed reproduction; repeat this squaring, enlarging it this time onto the surface where the copy is to be painted. You'll then draw the picture, making use of this grid procedure. It is the method described in this book for copying Pissarro's *Entrée de Village* and Cézanne's *Le Vase Bleu*. Then you'll be all set to go to the gallery with the image already blocked onto the canvas and ready to be painted.

6. As a general rule, museums and galleries do not permit making exactly life-size copies of the original. At the Metropolitan Museum of Art in New York, for example, copies must differ in size from original works by at least ten percent, and canvases may not be larger than 30 × 30 in. (76.2 × 76.2 cm).

Summary of regulations for copying
works in museums

Most major art museums permit artists to copy works in their collections, provided you abide by established rules and regulations. Rules for copyists vary from museum to museum; those presented here are only general guidelines. For detailed information, contact the museum.

1. Once you have obtained a list of the necessary rules and regulations and have chosen the work you wish to copy, you must apply to the museum for a copyist's permit. In some cases, permits are issued through the museum's education department; in others, you may have to apply to the specific curatorial department in which you wish to work. To find out how and when to apply, call the museum or inquire at the information desk.

2. Copying permits are valid for a specific duration, for as long as perhaps one to three months. Some museums require that you carry your permit at all times while working there, and return it before removing your work from the museum. Only the painting or object specified on the permit may be copied, and not all objects are available for copying.

3. Always call the museum before you arrive to see if the gallery you wish to work in is open that day for copying. The hours during which copyists are allowed to work are usually limited.

4. Copies must differ in size from the dimensions of the original, and some museums specify a maximum permissible size. Typically, your canvas will be dated and stamped to indicate that permission to copy has been granted. Then, before you are allowed to remove the canvas from the building, it will be stamped or otherwise documented as a copy from the original.

5. Many museums keep easels on hand for copyists to borrow, and provide storage racks for canvases in progress. Drop cloths, paints, palettes, brushes, and any other equipment are the responsibility of the copyist. Never leave canvases or other materials unattended in a gallery; the museum cannot be held responsible, and you may risk having your permit revoked as well. Always take care not to get paint on museum property. Clean painting materials at home.

Methods of composition

Observing the above-mentioned procedures, and with the idea of painting the picture *Entrée de Village* , let's imagine that we have gone to the archives or offices of the Orsay Museum and asked for the exact measurements of the picture, the type of surface it was painted on, and the materials Pissarro used.

The original title of the picture, *Entrée de Village*, translates into English as *Entrance to the Village of Voisins*, which is how we shall refer to it on the following pages.

The original picture is 18⅛ in. high and 21⅝ in. wide (46 × 55 cm). Since the copy is not permitted to be the same size, it is obvious that:.

You must work with a different stretcher size, either slightly wider and higher or slightly narrower and shorter.

In this case, a difference of an inch or two for each dimension should suffice. The relatively small size of the picture corresponds to measurements commonly used by the Impressionists, who, apart from their usual lack of money for buying big canvases, could not exhibit in the Paris Salon, and so had to content themselves with hanging their pictures in small private galleries such as those in the rue Peletier or rue Lafitte. Moreover, Impressionism—capturing an *impression* of a landscape—was ill suited to working on a large scale.

Camille Pissarro painted this picture in oil on thick, coarsely woven canvas in the year 1872, shortly after returning from England. The fact that on leaving London he went back to his studio at Louveciennes in France led to the belief that this view corresponded to that particular place. It was later demonstrated, however, that this "entrance," or road, belonged to the village of Voisins, a few kilometers from Louveciennes.

The composition of the picture *Entrance to the Village* corresponds to a formula Pissarro used several times, probably remembering certain of Corot's landscapes. It is a classic formula by which one establishes comparisons between sizes, proportions, and positions of objects in space to create in the mind's eye the illusions of distance and depth. Sisley and Cézanne also used this method of composition. Monet, on the contrary, preferred to suggest depth by means of large points of reference rendered in the successive planes of the picture. Pissarro, overheard once in a conversation with Monet on this topic, is said to have made the following offhand remark: "I can't avoid painting roads and highways; my house at Louveciennes is right on the road leading to town."

Enlarging upon these observations, which are applicable to landscapes in general, let's look at the next page. Here we find examples of three formulas Pissarro used to represent the idea of depth, or the third dimension, in landscapes.

Fig. 67. *Dulwich College*, Pissarro (J. A. Macauley Collection, Winnipeg, Canada). The third dimension—depth—is achieved here by means of a prominent foreground. Note the tree trunk on the right.

Fig. 68. *Le Pont Neuf*, Pissarro (Collection of Mr. and Mrs. William Coxe Wright, Philadelphia). In this case, depth is accomplished by the disappearing lines of perspective.

Fig. 69. *Woman in a Field*, Pissarro (Orsay Museum, Paris). Here depth is rendered by the overlapping of planes, which is to say, by the succession, one in front of the other, of the planes formed by the trees, the wall in the background, the trees and houses in the background, and so on. This, by the way, is one of the pictures from Pissarro's *pointillist* period.

67

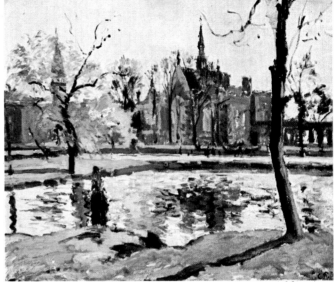

68

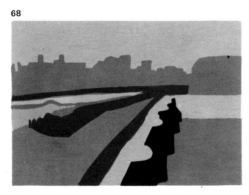

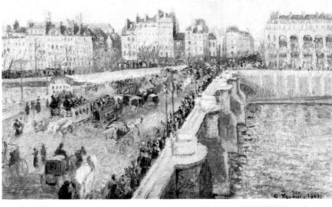

69

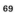

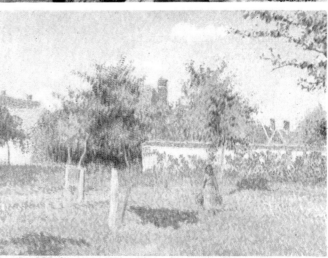

Materials used by the Impressionists

It's interesting to discover that the tools and materials used by artists, both for drawing and for painting, have changed very little over the last hundred years. The types of easels (both indoor and outdoor models), the quality of canvases and stretchers, the pencils, charcoal, painting knives, brushes, solvents—everything—is just the same, except, of course, for the quality of oil paints. Commercially manufactured oil paints first appeared on the market in zinc tubes around the year 1860, but the colors that you and I use now are of a much higher quality. Regarding the rest, you can see for yourself that there is very little difference.

Easels
There is no difference between the old and the new. The easels used by the Impressionists were, in fact, virtually identical to the ones pictured in Figs. 70 and 71.
Chairs were used instead of stools. The side table served the same purpose as it does now.

Canvases
The painting surface was prepared much as it is today with four strips to form the frame and wooden wedges for stretching the canvas. Canvases were made of linen, still the material of choice, with preference given to medium weave (Figs. 72 and 73).

The palette
Palettes were oval or rectangular in shape. Here I would like to draw attention to the placement of colors on the palette (Fig. 78), since this will help you to organize your painting better.

Paintbrushes and knives
Just like those of today, the paintbrushes used a hundred years ago were made of soft bristle in three basic shapes: round, flat, and "cat's tongue" (filbert). Regarding knives, two typical shapes were used, one that resembled an actual knife, and another in the form of a small bricklayer's trowel (see Figs. 74-76).

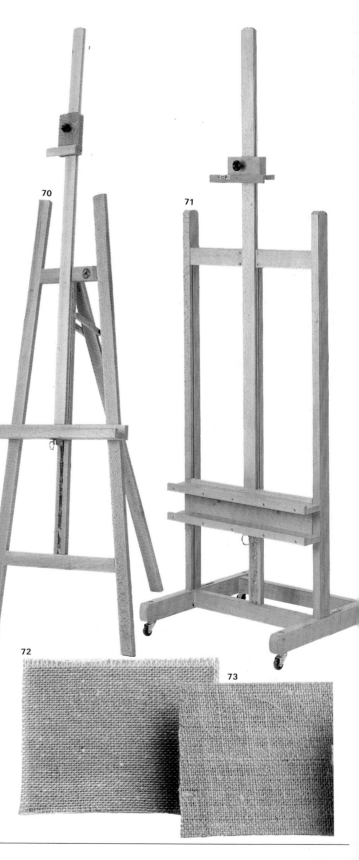

70

71

72

73

Miscellaneous tools

The solvents were the same: turpentine and linseed oil, generally used in equal proportions, with copal varnish also being used for the final varnishing of the picture. Oil containers were practically the same, and, just as today, charcoal was used to sketch the picture onto the canvas. One small innovation is worth mentioning. Nowadays, we can quickly and easily fix the charcoal sketch by means of a fixative spray.

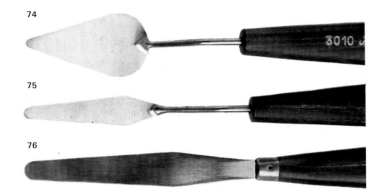

Figs. 70 and 71. These are the types of easels most used by painters. Both of them allow the painter to choose the height he wants to put his painting. They adapt to the different formats of canvases. The easel in Fig. 70 is very comfortable for medium-size canvases.

Figs. 72 and 73. Traditionally, linen has been the material used for making canvases. Their quality varies according to the thickness of the fabric's grain. The more dense its texture, the bigger the grain, and consequently, more paint may adhere to the canvas.

Figs. 74-78. Both the oil containers (Fig. 77) and the palette knives (Figs. 74-76) are the same as they were 100 years ago. Cézanne was one of the first artists to paint in oil with a palette knife. On a typical oval-shaped palette (Fig. 78), colors are arranged around the perimeter and mixed in the center.

Figs. 79-81. Now, as in Pissarro's time, paintbrushes have soft bristles and come in round-tipped (Fig. 79), flat-tipped (Fig. 81), or filbert (Fig. 80) shapes. Sable brushes were and are also used. Synthetic brushes, however, are increasingly popular. Aerosol spray is now used for fixing charcoal sketches and preliminary drawings.

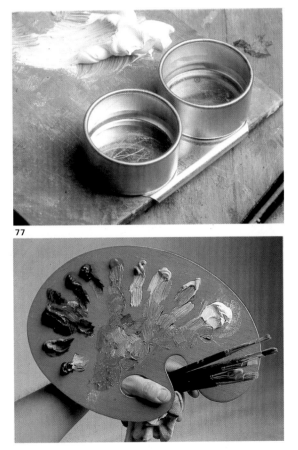

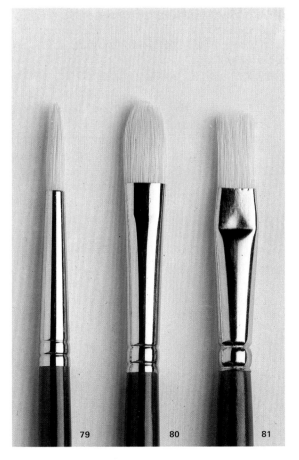

Colors of the Impressionists

In 1869, three years before the date of this picture, Monet, Pissarro, and Sisley suddenly felt a genuine passion for painting snowy landscapes, not only because the dark brown-black of the tree trunks and branches reminded them of the arabesques and elegant contrasts of Japanese prints, but also because this was the period in which Impressionists were painting with theories of the French chemist Michel Eugène Chevreul in mind, trying to investigate and prove that *light was color and color was light*, that shadow meant not darkness but *reduced light* and *reflected light*.

Let's think, then, of the efforts made by all Impressionists, but most especially those of Pissarro, who was trying to rid himself of the grays, ochres, and browns inherited from Corot. In Pissarro's pictures—and for that matter, in the work of all the Impressionists—there always remained that link with the past, that abiding use of color to blend and harmonize the discordant tones. Chevreul's researches on color contrast had awakened in the artist the realization that all colors in nature were composed of three primaries: blue, yellow, and red. We can thus determine quite easily the colors used by Camille Pissarro in 1872: *the three primary colors plus another red, an ochre, and a green*. In practice they were the same colors that a modern-day artist uses, only at that time, and because of Chevreul's influence, the Impressionists attached special importance to blue, yellow, and red as the true basic and primary color.

Maurice Busset, a renowned French artist and the author of books on painting technique, was born in 1897, making him a contemporary of Monet. He tells us in his book *The Modern Technique of Painting* that the Impressionists painted with very few colors, some in fact with only four: ultramarine blue, cadmium yellow, cadmium red, and emerald green. He admitted that this assortment could be widened to include deep madder, yellow ochre, and burnt sienna as a substitute for black. Here, then, is the basic palette (Fig. 82):

PALETTE COMMONLY USED BY
IMPRESSIONIST ARTISTS

Titanium White
Yellow Ochre
Cadmium Yellow Medium
Cadmium Red Medium
Deep Madder
Emerald Green
Ultramarine Blue
Burnt Sienna

There is no black in this palette. We must suppose that the Impressionists made black just as we do today, by mixing ultramarine blue, deep madder, and burnt sienna, adding one color or another depending on whether they sought a cold or warm black.

Titanium white

Yellow ochre

Cadmium yellow medium

Cadmium red medium

Deep Madder

Emerald green

Ultramarine blue

Burnt sienna

83

Fig. 83. These are the two standard-size tubes for oils. The larger size, containing 5 oz. (150 ml), is recommended for the color white because it is used more than the other colors.

A study of *Entrance to the Village of Voisins*

At this point there are two important things to remember:
1) Pissarro painted in a thick, dense, and opaque manner.
2) Pissarro painted by "dabbing," using short, broken strokes.

To confirm the first of these two points, we need go no further than to look at the reproduction of *Entrance to the Village of Voisins* and study its execution. Even a person totally unfamiliar with art can see at a glance that there is a considerable thickness of paint in the picture, especially in certain places that clearly have been painted over. This leads us to an extremely important conclusion:

Pissarro painted in oils using techniques of layering.
You are probably aware that in oil painting there are two main techniques. In the first, or direct technique, the artist finishes the picture at a single sitting, with an initial outline sketched in turpentine-thinned paint, which can then be immediately worked over with a thick application of paint. The option is to apply layers of paint, one on top of the other, over several painting sessions. Special effects are achieved through rubbing, scraping, glazing, and so on.
The Blue Vase, by Cézanne, is a good example of the direct technique, of a picture that is nearly resolved in a single session. *Entrance to the Village of Voisins*, on the other hand, is a clear example of a painting that has been built in stages. Perhaps very quick stages, with the most important work being done from one day to the next, when the paint was still damp, but stages just the same.
Just look and see for yourself.

The tree trunks. It is clear that Pissarro painted those dark tree trunks first, and later, at a second sitting when the paint had begun to dry, picked out the highlights using bright colors. Observe the rough texture of the trunks, painted thickly on top of dry or semi-dry colors.

The thin branches against the sky. Observe the series of fine brushstrokes that must have been added when the sky was completely dry.

The touches of sky blue over the tops of the trees. Notice those touches of sky blue, added in a final session, over the mass of ochre-sienna formed by the tree tops. See how in painting with sky blue over the still-soft ochre, the two colors mix to form a kind of light green. Yes, indeed, Pissarro painted by stages; he never improvised. As the art historian John Rewald says, his pictures were the product of an "analytical perception," which is to say a way of observing and analyzing the subject in an attempt to capture an overall impression that is neither sudden nor disjointed. It has even been argued that this solid, balanced manner of painting contradicted the theories of Impressionism. But the consensus is that, although Pissarro always considered a slow and carefully thought-out execution of the work to be essential, in the end he had the gift of being able to express that feeling of lightness, of spontaneity, of first intention that is so characteristic of the Impressionists.

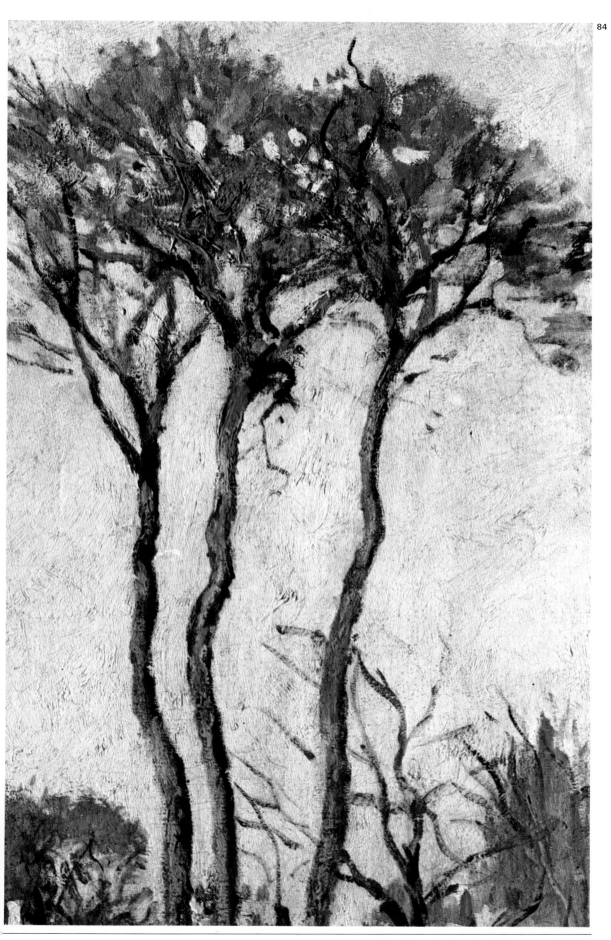

How Pissarro painted

Let's analyze the other pertinent aspect of Pissarro's techniques:

Pissarro painted with short strokes.
During the period in which Cézanne and Pissarro painted landscapes together at Pontoise, a peasant who had spent a long while observing them was to remark that Cézanne painted flat with wide brushes, while Pissarro stabbed at the canvas with long, thin brushes. It appears that Pointillism—which was to unite Pissarro with Seurat and Signac—had already come into play here. And it was with this very technique that Pissarro would achieve his most important effects, that vibration of color born from the juxtaposition of tiny brushstrokes, each one suggesting a subtly different nuance in color.

He painted randomly, making short stabs, wetting and frequently reloading the brush in order to attain those subtle little nuances of color in a single area.
Using Pissarro's color range, I want you to try to mix and match the twelve patches of color seen on the facing page. You will see that by adding greater or smaller amounts of yellow ochre to just a few other colors, you can achieve all the hues and nuances present in Pissarro's picture, with the exception of the blue used in the sky and in the sides and roofs of the houses.

Thus we can see that those twelve color swatches have yellow ochre as their base, that yellow ochre is therefore the predominant color in this picture. So remember to have a larger amount of yellow ochre pigment ready on the palette, and don't forget that you will need to use it in all—or almost all—of the color mixes.

Here is where my comments and preliminary advice come to an end. We will now begin the practical work, the drawing and painting of the picture.

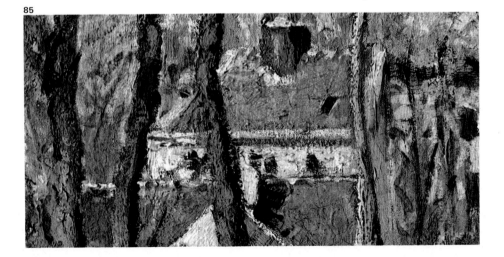

85

Fig. 85. Observe in the detail of *Entrance to the Village* an example of the chromatic richness Pissarro achieved in spite of painting with a color range in which yellow ochre predominated.

Predominant color: yellow ochre

86

Fig. 86. On the left is the color yellow ochre just as it comes out of the tube. Bear in mind that it is used in almost all the mixtures that make up *Entrance to the Village*. Experiment for yourself by mixing and making up the following colors, which are described in order from left to right beginning with the creamy hue in the top row.

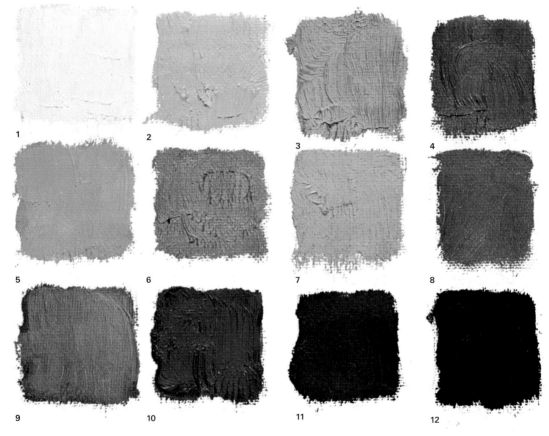

1. **Cream color of the houses:** composed of white, yellow ochre, and cadmium yellow.

2. **Color of the earth, light parts:** white, yellow ochre, and a little ultramarine blue.

3. **Ochre color of the trees in the background (illuminated part):** white, yellow ochre, ultramarine blue.

4. **Darker color of shadowy parts of the treetops in the foreground:** white, yellow ochre, burnt sienna, deep madder, and emerald green.

5. **Orange-colored rooftops:** yellow ochre, cadmium yellow, a little white, a little cadmium red, and a lit-tle emerald green. (Emerald green or ultramarine blue are always used sparingly and usually with the purpose of toning down color.)

6. **The shadow on the wall in the background and the house to the left in the foreground:** yellow ochre, white, deep madder carmine, and ultramarine blue.

7. **Highlights or lighter parts of the grass:** yellow ochre with a little cadmium yellow, white, and a little emerald green.

8. **Medium and dark greens:** yellow ochre and emerald green.

9. **The green-burnt sienna of the** shadowy parts: yellow ochre and ultramarine blue. (To obtain a more brilliant green tint, add yellow gradually.)

10. **Blue-green black:** yellow ochre and ultramarine blue.

11. **Black-deep sienna:** deep madder, emerald green, and burnt sienna. If you wish to highlight the brown tone, add red.

12. **Blue-black:** ultramarine blue and a slight touch of deep madder, keeping the blue tone.

Observe that, with the exception of the last two colors, yellow ochre is used in all the mixtures.

Mixtures and color samples

Fig. 87. Here are some examples of color mixes used in different areas of *Entrance to the Village*. Note the use of yellow ochre in all—or almost all—of the colors in these swatches.

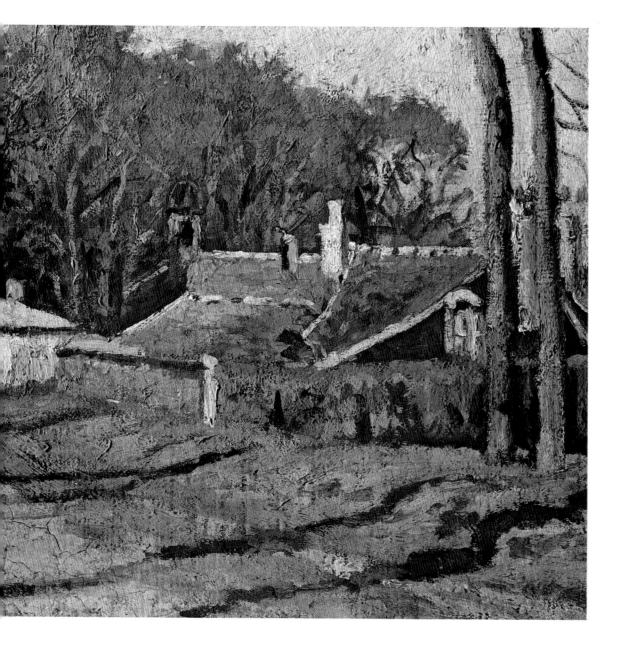

Drawing with the aid of the grid system

Your canvas should be on a stretcher with dimensions of, let's say, 18×21 in. $(46 \times 55$ cm), sufficiently different in size from the original to abide by museum regulations. Start by making a postcard-size copy of the picture using the grid method—the method that transfers an initial drawing to a different surface, in our case, from sketch to canvas. You will be *squaring up* from a smaller grid to a larger grid—copying the lines of your postcard-size drawing of the subject into the squares of an enlarged grid you'll draw on your canvas.

I. From the next page cut out the "postcard," which is $4\frac{1}{4} \times 5\frac{1}{4}$ in. Using $\frac{3}{8}$ in. (1 cm) as the basic unit will produce eleven vertical parts and thirteen horizontally, so with a ruler, mark the postcard every $\frac{3}{8}$ in. (1 cm) on all four

edges and draw a grid. You will have a fraction of an inch (4 mm) left over, as you can see in the illustration below.
II. Dividing the height of the canvas, 18 in. (46 cm), by eleven, the basic unit of the small grid, will produce a unit of $1\frac{3}{5}$ in. (4.1 cm), which becomes the basis for the enlarged grid with a fractional column left over. With your ruler, mark the division points and, using a charcoal stick, draw the lines onto your canvas.
III. The same factor of $1\frac{3}{5}$ in. (4.1 cm) will divide the width of 21 in. (55 cm) into eighteen parts. Note: This horizontal division must be done from *left to right* so that the fractional portion left over will be proportional to the vertical measurement. Mark the vertical divisions and use your charcoal to draw those lines.

88

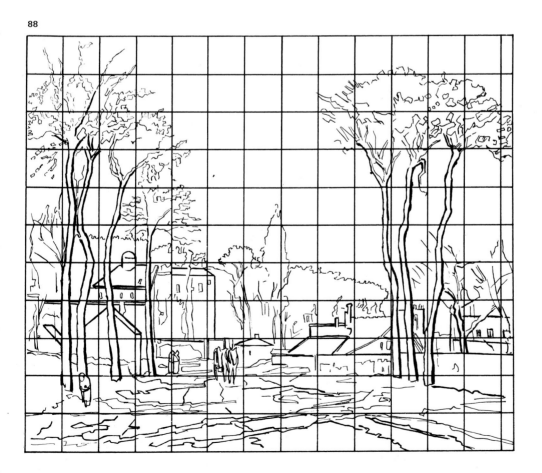

One important matter needs explaining: Due to circumstances beyond our control —arising from the dimensions of the photograph supplied to us for the large-size reproduction of Pissarro's *Entrance to the Village of Voisins*—the top part of the picture has been slightly cut off. Part of the sky and part of the earth are missing.

To appreciate this small difference, place the color plate and the postcard-size reproduction side by side. Note the signature, *C. Pissarro, 1872*. In the small-scale reproduction the signature appears in its entirety, the tail of the number 7 being long and whole, while in the color plate the signature appears with the tail of the 7 cut off. The problem is not serious if one is aware of it. It's merely a question of painting from the reproduction, but bearing these little differences in mind.

In any event, we suppose that you have finished laying out the grid and that you are now ready to enlarge the scene by sketching it onto the canvas with charcoal.

89

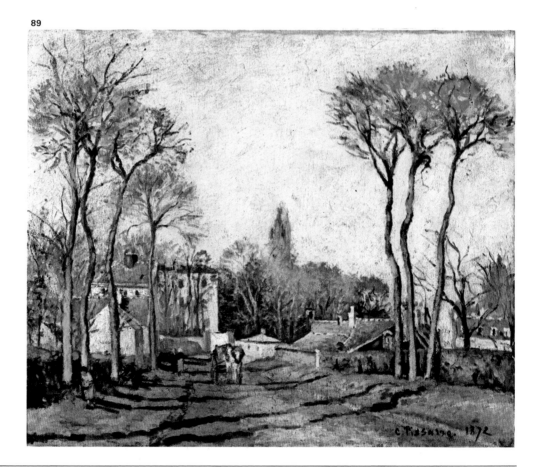

First stage: drawing and composition

Look at the way this drawing, now finished on the opposite page, has been resolved. Observe that the construction has been very carefully done, perhaps excessively so in places. Here we must remember the influence and advice of Corot, and the need for good construction, in order to understand that Pissarro was not one to leave the drawing of his pictures to chance. Confirming this rule in one of his letters to his son Lucien —also a painter—Pissarro said in this respect, "A few little sketches won't do. You've got to do lots of them. If you want to be able to capture the character of the whole quickly and to reflect it, then you've got to work hard and well. Lots of drawing, Lucien, lots and lots of drawing."

Be especially careful with the volume, proportion, and dimension of the houses in the background, in the curve and drawing of the basic lines that, as they disappear into the background, make up the road and its borders. Remember that all subsequent shapes—the tree trunks and treetops, the shadows they cast onto the road, the figures, and the cart in the center of the picture—will be placed on top of these initial forms.

Now draw the trees and the tops of the trees, undeterred by the fact that in a few moments, when you paint the sky, you will eliminate all, or almost all, of this drawing. Bear in mind that, as Pissarro himself said, "one must get used to capturing the character of the whole," something that can be done only through

"knowing the model," drawing it so that its shapes remain imprinted on the memory.

Now, if you are ready, you can fix this drawing with a spray so that you'll be able to paint over it with no problem. Naturally, back in the year 1872, fixative sprays did not exist. Pissarro probably did what everyone did in those days, when the common practice was to pat the charcoal drawing with a cloth to remove the excess dust. I don't think that the method used is important in this case. What *is* important and useful is to make

and fix this preliminary charcoal sketch. Without further comment, and with brushes and rags at hand and all colors prepared and arranged in correct order on the palette, let us paint.

90

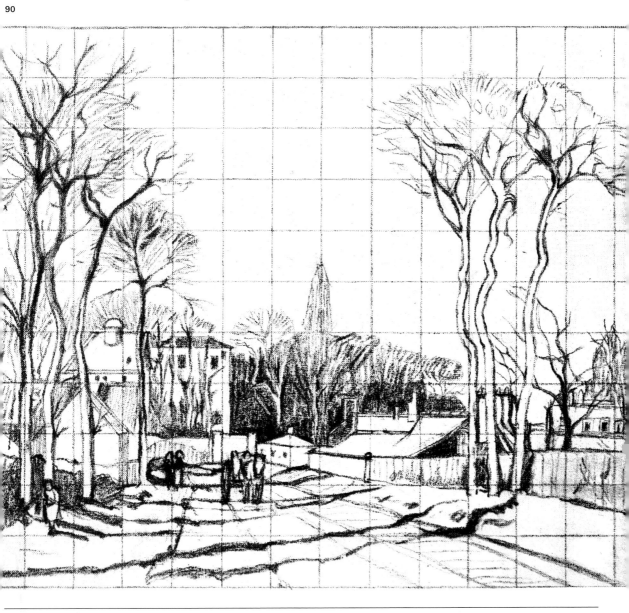

Second stage: establishing the color scheme

Practically all the colors mentioned earlier will be used. Paint with sizes 6, 8, and 12 soft-bristle brushes.

First, the sky
The basic color is white. You must gradually add small quantities of ultramarine blue until you obtain the tone of Pissarro's sky. What's missing now is a touch of yellow—just enough to achieve that ever so slightly greenish quality (see the color plate). And you also need the tiniest speck of deep madder to tone down the color blue a bit. Apply the paint quite thickly and in separate short strokes, almost tapping the brush on the canvas the way you might tap a pencil, just as Pissarro did. Don't worry for the moment about where you're going to put the trees, horizon, and so on. Remember that Pissarro didn't concern himself over allotting these spaces either. It doesn't matter if you "go too far." Later on, in the following stages, you can always paint and repaint over the blue of the sky.

The roofs of the houses
There are lots of colors involved here, aren't there? To begin with, the yellow or ochre with a bit of deep madder or white make up the siennas. But you'll need a little ultramarine blue—you'll have a bit of that blue already made up for the sky—to tone down and dull the orange color, bearing in mind that the more blue you use, the more those roofs will tend toward dark sienna.

Finally, where the brown rooftops are very dark, you should use mostly burnt sienna.

The walls of the houses
In all the color mixtures in this painting, blue is invariably used. The pale blue you concocted at the beginning for painting the sky is fine for toning down and blending other areas; you can mix it with all or almost all of the light colors. On the walls of the houses, white, ochre, and yellow—plus just the tiniest speck of blue—are the predominant colors.

Our aim is still, of course, to paint those walls and roofs without bothering, for the time being at least, about the trunks and branches of the trees. We know all that will come later.

The earth
The general tendency is yellow ochre with very little white. Add a little emerald green, plus a little burnt sienna and an even smaller amount of deep madder. Don't overdo the white. Remember that white is not used for lightening colors. It's necessary in some places but you should try to be sparing in your use of it.

The color of the grass
The grass is basically made up of ochre and emerald green. The other colors, including white, should be used only to enrich and vary your rendering· of the grass.

Trees in general

With yellow ochre alone, just as it comes out of the tube, you can paint the treetops and generally all the light areas of the trees, such as those that appear in the background, behind the houses. I repeat, no white, only yellow ochre. Nevertheless, for varying and enriching the color it may be necessary to add a few touches of a mixture of burnt sienna and emerald green, as well as cadmium yellow in the lighter areas.

Tree trunks and shadows

Basically the color of the tree trunks and branches, the shadows and dark areas in the background woods, and those dark patches at the foot of the trees, is burnt sienna. You should vary this color in some places by mixing it with green or deep madder.

91

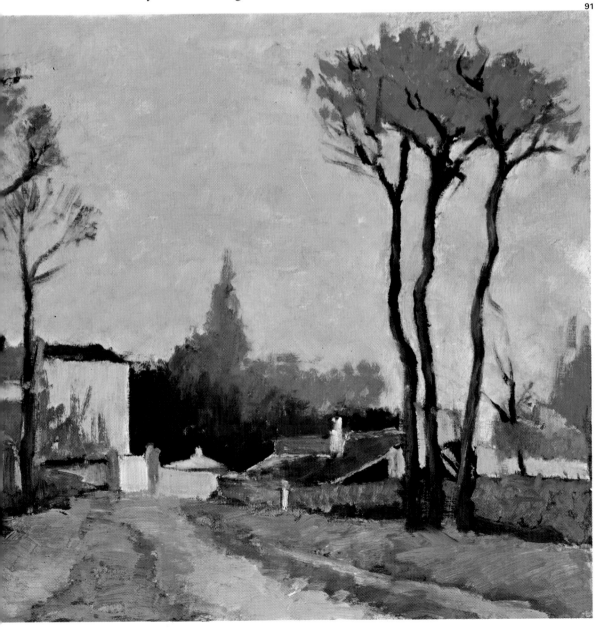

Third stage: finishing the picture

Finer brushes are used at this point —no. 4 and no. 6. Use them to define and draw the shapes in greater detail. Before you go on painting in this third stage or session, allow me to remind you of two extremely important aspects:

The paint must have time to dry between one session and the next.
Remember that in order to achieve the finish we spoke of, that is, thick, bold paint applied over an already painted area, it is absolutely essential that the previously painted area be dry, or almost dry, and that it provide sufficient "grip" for the new layer of paint to be applied over the earlier one without the two layers of color mixing.
1) During the first session, always use turpentine as a solvent so that the colors dry more quickly.
2) Allow at least one day between the first and the second sessions, thus facilitating the drying of the paint.

The predominant color is yellow ochre.
As you've seen in the first stage, yellow ochre is used in almost all of the mixtures, and in almost every area of the painting—very often as the basic color, occasionally as accents. Since the entire color scheme springs from yellow ochre, with the minor exceptions of a couple of the darks, you must keep that fact in mind when mixing your colors.

Start with the treetops.
Now our goal is to stick much more closely to the shapes and colors in the reproduction. You'll have to work more slowly and in much greater detail. Remember that you are painting a copy and that the more faithful the copy is to the original, the better it will be, and the more useful this will be as an exercise. You have to begin to consider and calculate every nuance, every brushstroke, every shape, no matter how small, and strive to achieve a perfect imitation.
For example, look at those tall treetops. You'll have to vary the color much more now, continuing to paint basically with ochre but without neglecting the different shades and colors obtained from the use of sienna or emerald green or deep madder in others.

Continue with the background trees, the earth, the grass.
Use practically the same colors you used for the treetops, adding yellow, white, and red here and there.

Be careful with nuances, with the shadows of the trees.
I mean those elongated shadows in the form of lines extending across the road, cast by the trees on both sides. Remember that basically the shadows were painted with sienna, which was varied, lightened, and otherwise enhanced with the help of emerald green, deep madder, and ultramarine blue. With regard to this, bear in mind that to depict a shadow that falls on a green background, you should use a mixture of emerald green and burnt sienna. For a shadow that falls on a background of light earth the color must be lightened by the addition of deep madder, ochre, or even a little blue and white.

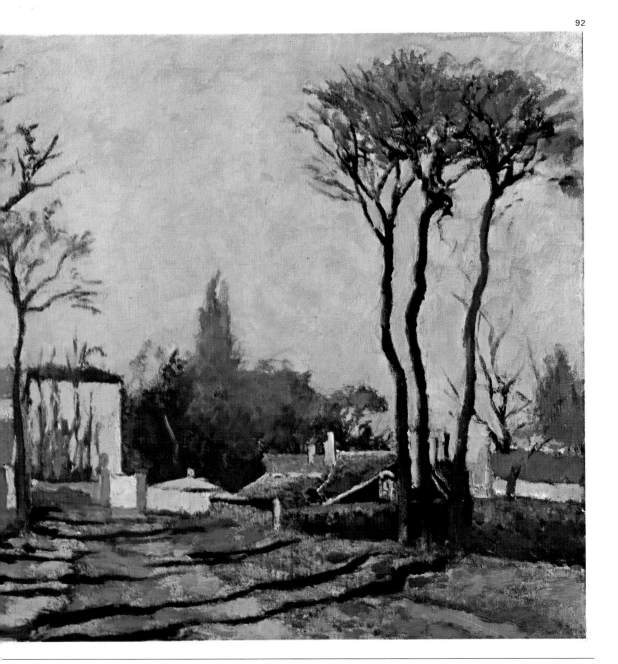

Use the same colors for the roofs and walls of the houses.
I hardly need to add anything more. You'll be painting with the same colors you used in stage one. Now you'll need to paint in much greater detail, with greater definition and precision.

92

Final stage of the picture

Allow at least one day between the previous stage and this one, thus giving the paint time to dry.

There is nothing, or almost nothing, we can say regarding the execution of this final stage that you are not capable of seeing for yourself in the color plate.

The colors are those that were used in the previous phases, with perhaps an occasional nuance that we have not specified. For example, in the left foreground, note the violet shadow on the side wall of the house; in the background at left, note the mix of sienna and gray in the woods; and look at the light blue strokes defining some of the rooftops. Still, I really don't think you will have any difficulty at this point in discovering and understanding those subtle differences in tone and color for yourself.

A thorough and meticulous observation of the reproduction will lead you, I think, to decide how best to solve certain problems: Consider Pissarro's formula designed to "open up the sky" between the foliage of the treetops. His method consisted simply of applying a patch of sky blue on top of the yellow ochre of the treetops; remember, too, that other technique of which we have already spoken, of illuminating tree trunks with very thick, dense ochre. The ochre should not be uniform; it must contain yellow in certain spots, while in others it should be mixed with a bit of white.

While we are on the subject of capturing the tone and the coloring of the reproduction, you might try the old trick of turning the picture upside down (in this case both the print and your copy) in order to perceive more objectively the correct coloring, both of specific detail and of the composition as a whole.

There remains one final bit of advice that I feel I should stress if you really wish to obtain a perfect copy:

Paint and copy everything.
We're not talking about making an absolutely identical, photographic copy, of performing a mechanical labor that would result in a counterfeit copy rather than an artistic study. It is not a matter of imitating the exact thickness of the brushstroke. But we do want to execute a good copy, artistically speaking. We want to analyze each line and color and think about "how Pissarro did it." As much as possible we want to paint as many branches and leaves as Pissarro did originally. The result will be a painstaking process, a study in the true sense of the word.

Try to analyze and to learn. Work things out for yourself. Decide, for example, if you should paint with thick or thin soft bristle brushes. Calculate the width and direction of your brushstrokes. Study, verify, and analyze. Later, when you have finished this exercise, you will have accumulated a store of skill and knowledge, of technique and method that you'll be able to apply to your pictures in the future. You'll feel within you the connection with and the influence of one of the masters of the Impressionist movement.

Like Manet, like Degas, like Renoir, like all the famous painters who ever went to a gallery in order to paint, you will be able to say:

"The technique of a great artist has worked in me."

Fig. 93. *Self-Portrait,* Cézanne (Orsay Museum, Paris).

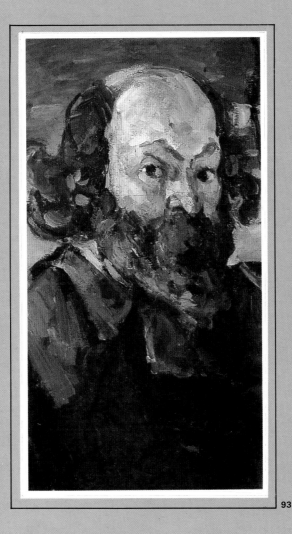

93

WHO
—WAS—
CÉZANNE?

94

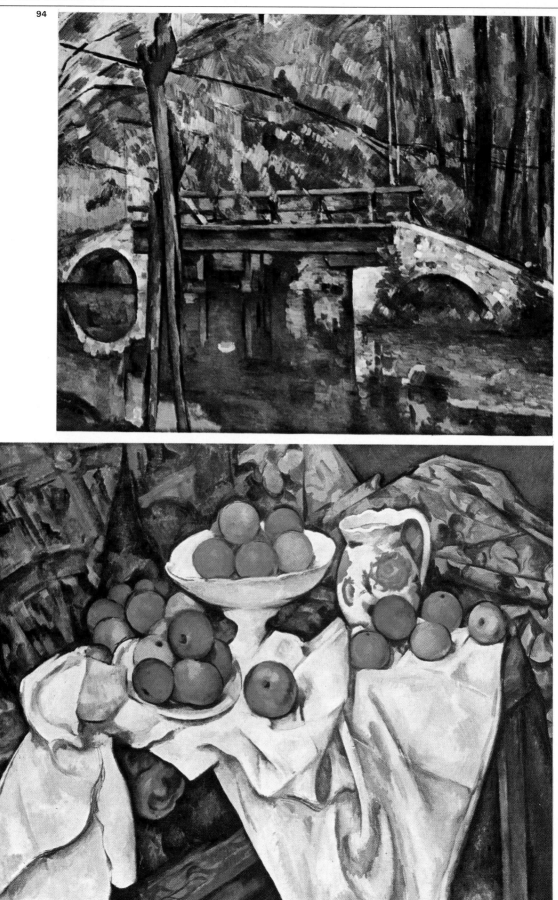

95

To be a painter

Fig. 94. *The Bridge at Maincy*, Cézanne (Orsay Museum, Paris).

Fig. 95. *Apples and Oranges*, Cézanne (Orsay Museum, Paris).

Fig. 96. *Victor Chocquet*, Cézanne (Lord Rothschild Collection, Cambridge, England).

In France during the mid-nineteenth century, Emperor Napoleon III encouraged the works of artists and artisans to an unprecedented degree. Paris became the artistic capital of the world attracting thousands of artists and would-be artists, mostly young people who were often neither gifted nor established in their chosen field. Living in studios, garrets, or basements in the older quarters of the city, they led bohemian life styles and were invariably beset with serious financial difficulties.

One day this throng was joined by a young man named Paul Cézanne, who arrived in Paris with similar thoughts of becoming a painter. He was born in Aix-en-Provence in 1839, the son of a haberdasher. Successful, prosperous Louis Cézanne envisioned his son as banker and lawyer. The younger Cézanne was educated at the Bourbon School in Aix, where he met Emile Zola, who was to become not only a celebrated novelist but a close friend to all the Impressionist painters. Paul finished school at seventeen and raised no objection when his father suggested that he should now study toward a law degree. But, while awaiting the start of the university academic year, he enrolled at the Aix Museum's Municipal Drawing School, in order, as he said, "to pass the time, to be doing something." And what happened

is that he soon won second prize in a drawing contest—which only muddied his decision about the future he should declare for himself.

Arriving in Paris at age twenty-two, after several years of desultory attention to law studies in the provinces and still torn about his life's work, Paul Cézanne asked his boyhood chum, "What should I do?"

"Be one thing or another," Zola replied. "A real lawyer, or a real painter. But don't be a nonentity with a paint-stained gown." It was Cézanne's own father who had paved the way for him to go to Paris, convinced that "Paul will come back cured of that painting fever."

"But you've got to enroll in the Shool of Fine Arts," insisted the elder Cézanne.

Once settled in Paris, Cézanne took the entrance exam in Fine Arts but failed—a new disappointment and further doubts. He returned to Aix to work in a bank. Cézanne did not abandon painting. Setting up a studio in a farmhouse that his father had acquired, he kept at it. Finally, he informed his father that he wanted to be a painter and that he was giving up banking for good. His mother and sister backed him up.

96

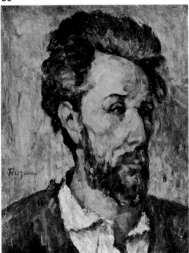

The versatility of Cézanne. The Impressionist painters were equally skilled at landscape, portrait, and still life, although each had his preferences. Manet occasionally painted a landscape or still life, but his famous pictures centered around the human figure. Degas never painter a landscape, while Monet, Sisley, and Pissarro did so almost without exception.

Cézanne was hugely versatile. A prodigious still-life painter, he also produced more than thirty self-portraits. And he studied the human figure endlessly, working on

the theme of bathers for nearly ten years. Around 1905 he finally finished *The Bathers*, a monumental work 8ft. (2½ m) wide by 7 ft. (2 m) high.

Although painting the human figure did not come as easily to Cézanne as it did to Manet, Degas, or Renoir, his decade of hard work paid off in what is now considered to be one of the most artistically advanced pictures of the early twentieth century. *The Bathers* would influence Derain, Matisse, even Picasso.

Cézanne the Impressionist

Cézanne returned to Paris accompanied by Zola, and the two visited the studios of the Impressionist painters. He met Manet, Monet, Renoir, Degas, and Pissarro, scrutinizing their styles. Often he would come across Pissarro at the Swiss Academy, a ''free'' studio-school unrestricted by the rigidity of the School of Fine Arts. Young artists often gathered there to draw and paint from live models. Meanwhile, Cézanne's father had agreed to a 200-franc monthly allowance. At least he wouldn't be going hungry.

Meeting the Impressionists, especially Pissarro, proved to be crucial. When he arrived in Paris, Cézanne was an admirer and follower of Delacroix, Géricault, and Courbet, and, like them, he was happy painting Romantic scenes, Baroque shapes, figures in dramatic stances, stark contrasts, and dark hues. But upon discovering the Impressionists, he embraced the movement and rapidly assimilated the new style.

In 1870, during the Franco-Prussian War, Cézanne took refuge in L'Estaque, a town far from Paris. There he painted and strove to lighten his palette, and also took up with his friend and former model, Hortense Fiquet. They were to have a son, Paul.

Finally, the war ended. Pissarro returned from England and Cézanne decided to follow the older artist, convinced that he was the great master of color and light. Journeying to Pontoise, a town northwest of Paris, then to Auvers-sur-Oise, Cézanne became friends with Pissarro and with the art connoisseur Dr. Paul Gachet, who years later would be van Gogh's physician.

97

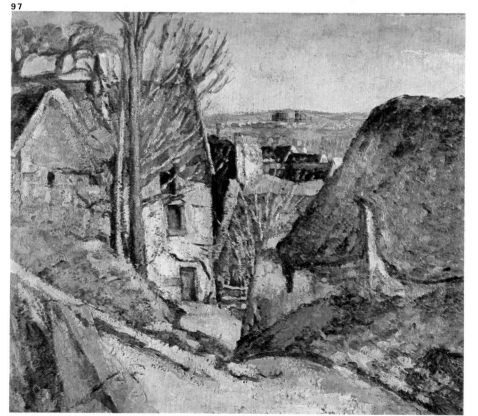

Fig. 97. *The House of the Hanged Man*, Cézanne (Orsay Museum, Paris).

Pissarro was a calm, steady, cordial man, a man with a warm heart and an open mind. Pissarro encouraged Cézanne, expressed his faith in his ability and his hope for Cézanne's success, all of which made the younger artist even more determined to surpass himself. "He is a man one can always turn to," said Cézanne, "and in a way he is like the Almighty."

Until 1872, to the majority of artists and, needless to say, to the admissions juries of the Paris Salon, Cézanne was a nobody. Or perhaps "eccentric" would be more accurate. For more than twelve years the Salon juries systematically rejected his pictures, but Cézanne, ever the optimist, continued to submit his work year after year in the hope of gaining admission.

After 1872, however, Cézanne's extraordinary artistic ability began to draw attention, so that by the end of the 1880s, it was Pissarro who was learning from Cézanne. "If you're looking for one in a million," wrote Pissarro to the critic Théodore Duret, "go and see Cézanne, as he has some very unusual studies, conceived in a unique way." And Duret himself wrote, "Cézanne developed a personal sense of color, harmonious in its violence, that others incorporated into their work. Then Pissarro began to paint with the vivid colors suggested by Cézanne."

98

99

Fig. 98. *Card Players*, Cézanne (Orsay Museum, Paris).

Fig. 99. *The Gambler* (pencil drawing), Cézanne (Louvre Museum, Paris).

Cézanne: looking beyond Impressionism

In 1874, thanks to Pissarro's efforts on his behalf, Cézanne was admitted to the first Impressionist Exhibition at Nadar's house. He also took part in the third exhibition in 1877, but subsequently distanced himself from the movement, feeling that it had little or nothing more to contribute or say to him. Returning to L'Estaque in 1878, he searched for new forms through new color harmonies. Cézanne was already thinking in terms of architectural volumes. This thought would one day culminate in a belief that the secret of art consisted of reducing all objects to such simple shapes as cubes, cylinders, and spheres.

In 1866, Cézanne had married Hortense Fiquet. That same year, his father died, leaving him a great fortune. For sixteen years the son had concealed from the father the fact that he and Hortense were living together out of wedlock, fearing that he would be disinherited. His father finally named him heir, knowing full well his son was not married. In 1866 Cézanne also broke with Zola over his book *L'Œuvre*, which centered around a painter—modeled too closely perhaps on Cézanne—who ends up a failure. Cézanne was given his first solo exhibition by the dealer Vollard in 1895. France requested his pictures for the Centennial Exhibition of 1900, and the National Gallery in Berlin bought one of his paintings. Maurice Denis then painted his famous *Homage to Cézanne*. In 1904, the Academy devoted an entire exhibition to his work at the Autumn Salon. Cézanne had triumphed.

Honors and applause were finally coming from everywhere, and Cézanne continued painting tirelessly. On October 20, 1906, at the age of sixty-seven, he went out as he did every day to work painting the hut at Jourdan. While working outdoors, he was caught in the rain; hours later, soaked and only half conscious, he was taken home in a launderer's cart. He had painted his last picture, given his last lesson on modern art. He died the next day.

100

Fig. 100. *Madame Cézanne in Winter* (detail), Cézanne (Stephen C. Clark Collection, New York).

Fig. 101. *The Hut at Jourdan* (Jucker Collection, Milan). This was the last picture by Paul Cézanne, painted a day before his death.

Fig. 102. In Mont Sainte-Victoire, Cézanne found an inextinguishable source of pictorial suggestions. The rich shades of the sky, the rocky structure of the mountain, and the variety of tones of the fields before it led the artist toward results such as the one in the photograph, that approach the abstract compositions we will find many years later.

Figs. 103 to 114. These are some of the fifty-five paintings Cézanne did of Mont Sainte-Victoire. Although they all repeat the same motif, each of them constitutes a single, unique piece of work resulting from this artist's continual search for different painting solutions.

101

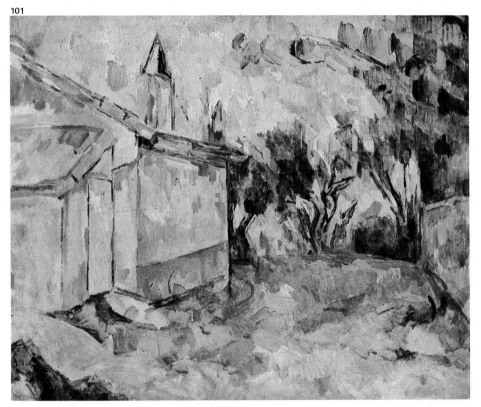

102

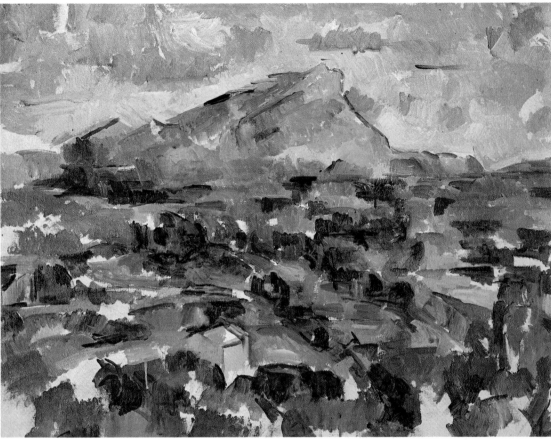

3

104

105

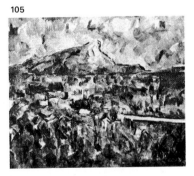

106

107

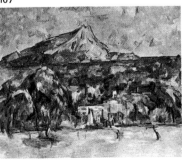

108

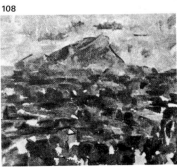

Mont Sainte-Victoire

It may surprise you to know that Cézanne painted Mont Sainte-Victoire fifty-five times. Fifty-five different variations on a single theme. Some were painted in a range of warm colors, others were cold. Some were barely sketched, others were finished down to the last detail. Some paintings looked as if they had been completed in a very short time.

Why did Cézanne go back time and again to a subject that, to the casual eye at least, offered such limited artistic possibilities? It is important to remember that Cézanne lived for some years in a house from which he could see Mont Sainte-Victoire and envision it almost as a finished picture. To grasp the logic behind this almost daily ritual, one must be familiar with Cézanne's ideas on the interpretation of a subject.

According to the painter Bonnard, a great friend of Cézanne's, the artist struggled all his life to represent subjects as he first saw them. To be sure, Manet, Renoir, Bonnard himself—everyone experienced this struggle. We still do so today. Bonnard explained the problem by saying that the picture is first and foremost an *idea*, an idea conceived in front of the scene to be depicted. One imagines it with qualities not present—other colors, different contrasts, even with other shapes. "But this initial idea," Bonnard went on, "tends to fade because the vision of the real model unfortunately invades and dominates the painter." Then the artist no longer paints his own picture. Claude Monet was terror-struck by the notion that his subject would take hold of him. He knew that if he spent more than fifteen minutes letting himself be guided by what he saw, as opposed to what he was thinking, he would be lost.

And Cézanne? What was Cézanne doing spending hours in front of one scene? Why was he conquering it, dominating it, capturing his own personal vision of it on canvas? I think that his secret of fresh visualization and conception lay in exercises like this one with Mont Sainte-Victoire, in painting a subject over and over again, each time in a different way. It was his discipline for learning the difficult lesson of not being tempted or seduced by the scene. Here is what Cézanne himself had to say on the matter: "When faced with the subject, I have a solid idea of what I want to do, and I only accept from Nature what is relevant to my ideas; the colors and shapes of the subject just as they are, relevant to my *initial conception*."

109
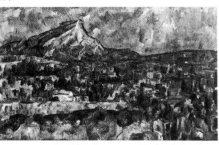

110
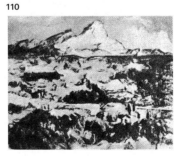

111

112

113

114

The Blue Vase

You have probably already seen the color reproduction of Cézanne's *Blue Vase* inside the back cover. As you did with *Entrance to the Village of Voisins*, fasten *The Blue Vase* to a surface where you can see it easily. Then set up the easel, stool, and side table. Make everything ready so you can start to paint this picture.

You'll see in the accompanying illustration (Fig. 115) a postcard-size reproduction of the picture. Cut it out so that you can continue with the grid procedure and the corresponding drawing.

115

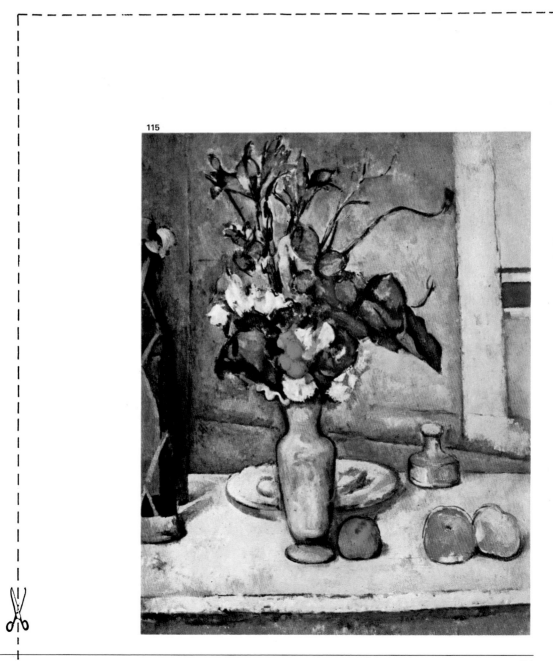

Of all the Impressionist painters, Paul Cézanne was the only one who never signed his pictures, nor did he leave any proof of when he painted his works. To determine dates, it has been necessary in the case of each picture to investigate Cézanne's own writings, letters, or notes. Some dates are precise, while others can only be approximated.

As a result of such research, it has been established that *The Blue Vase* was painted around 1866, the year he and Hortense Fiquet were married. It was also the year his father died.

The original picture is 24 in. (61 cm) high and 19⅝ in. (50 cm) wide.

Cézanne was 27 when he painted *The Blue Vase*. By then he was painting without the guidance of Pissarro, studying and finding shapes and colors that would lead him beyond Impressionism. *The Blue Vase* is a perfect example of Impressionism at its most advanced. As you can see, it's not a composed and prepared subject but rather a *motif*, something "which just happened to be sitting there on the table," captured seemingly spontaneously. The framing of the picture, with that bottle of rum (on the left side) deliberately cropped, and opposite, a bright-colored drape, chapped at the base, reflects the snapshot technique the Impressionists gleaned from Japanese prints. This idea of *painting the first impression* is heightened by the speed with which it was executed. Evidence of a certain haste can be seen in areas that have been left unfinished—the upper parts of the flowers, the inkwell, one of the apples. Yet *The Blue Vase* also offers an unprecedented coloration, colors so bright and luminous that they astonished all the Impressionists, beginning with Pissarro. They felt that Cézanne was the most progressive of their group.

116

Fig. 116. This detail of *The Blue Vase* shows us just how quickly Cézanne painted this picture. Notice the spots on the canvas left unpainted, the pencil lines that define the apple, and, in general, the thinness of the paint, an obvious sign of the *alla prima* or wet-in-wet method of painting.

Cézanne's painting method

As I suggested earlier, it seems safe to assume that all the Impressionists used, if not the same palette of colors, then at least very similar ones (see my comments on pages 46 to 47).

Remember, too, the peasant who saw Pissarro and Cézanne working together, and noticed that Cézanne "painted flat with wide brushes." Allow me to stress this observation.

Cézanne painted with wide brushes, which permitted him to work with broad strokes.

However, it is also significant that Cézanne alternated the use of wide-tipped brushes, nos. 8, 12, and 14, with narrower yet still flat ones, nos. 4, 6, and 8. In this connection, look at the image below (Fig. 117), which is a detail from the picture *Still Life with Peaches and Pears*. Notice the whiteness of the tablecloth and the ochre of the pear (marked A), which were painted with a wide-tipped brush, no. 12 or 14. Certain shadows on the tablecloth and on the pear itself were also achieved with a flat brush, but this time a narrower one, no. 4 or 6 (marked B).

The beginnings of a picture can be illuminating—the approach an artist takes in seeking solutions are often more clearly seen in unfinished pictures. Some of Cézanne's methods can be revealed by careful study of Fig. 118, which depicts his unfinished *Still Life with Vase* (Tate Gallery, London).

The first thing we notice about this picture is that Cézanne never concentrated exclusively on one spot at any given time. No, Cézanne "puttered about," to use Ingres's phrase, painting here and there without finishing anything, yet keeping everything at about the same level of completion, looking at the scene overall and painting it equally, all at once, in an unhurried yet unrelenting fashion.

Fig. 117. *Still Life with Peaches and Pears* (detail), Cézanne (Pushkin Museum of Fine Arts, Moscow).

117

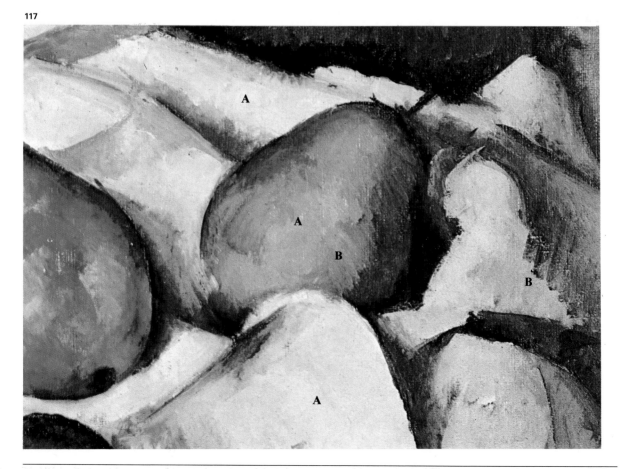

Fig. 118. *Still Life with Vase*, Cézanne (Tate Gallery, London).

Cézanne did not begin a painting by drawing in a meticulous, absolute fashion. A few lines, a quick sketch were all he needed to start painting. Just look at some of the lines in Fig. 118, sketched rapidly, simply suggesting the forms.

In this illustration we see that, once Cézanne had drawn a quick charcoal sketch, he used a round-tipped brush loaded with a dark gray tone (a mixture of ultramarine blue and burnt sienna with lots of turpentine) to restate, more precisely, the composition. But remember the following:

Cézanne drew and painted simultaneously.

In other words, apart from some quick touches of liquid paint with turpentine (see Fig. 117 and tablecloth in Fig. 118) he painted from the first brushstroke with the final, real color and with the desired thickness. In the gray vase, for example, there were practically no additions. Notice that in all instances he also painted the background using this quick method, creating accurate contrasts by balancing and adjusting colors as he worked.

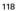

118

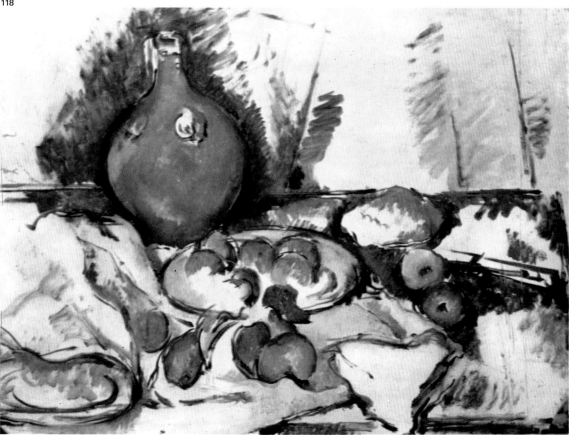

Predominant color: blue

Cézanne was a master of contrast. In composing his still lifes, he always sought to improve and enrich the works through a diversity of color and tone. In *The Blue Vase*, he took pains to make grayish-blue the predominant color. Yet he tried to bring about maximum contrast by juxtaposing the blue vase and the red fruit. He surrounded his subjects with a blue shadow. A similar effect was created by the placement of the white and red flowers, which are also surrounded by deep greenish-blue.

Look at the different samples on this page in which the predominant color is indeed blue.

1. Basically emerald green with a little burnt sienna. Cadmium yellow medium gives brilliance.

2. Add just a little yellow to white and cobalt blue to achieve a warmer color.

4. General background color made up of cobalt blue, white, and burnt sienna.

3. This is the same color as 2 with some yellow and perhaps a little ochre added to reflect the greenish shade in the background.

6. In the vase, the blue has a yellowish, and sometimes pinkish, tendency. Prepare mixture 5, adding some yellow or deep madder.

5. The color of the lighter part of the vase can be achieved by mixing ultramarine blue and white with just a speck of burnt sienna.

7. Basically white, cadmium yellow, and yellow ochre.

8. There is no doubt about the red apple: cadmium red and deep madder, with ultramarine blue for the shadows.

9. Note: On the table there are also bluish-gray areas or patches made up of white and just the tiniest amounts of blue, deep madder, and yellow.

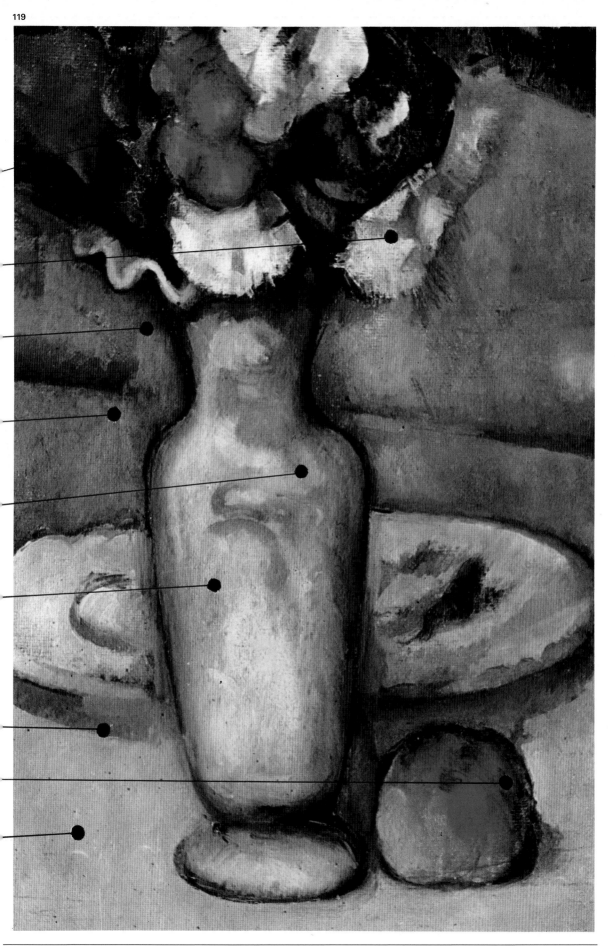

Drawing with the grid system

The postcard-size reproduction of *The Blue Vase* (p. 71) you have cut out is exactly 5¼ in. (133 mm) high. If you divide this vertically into twelve even spaces, you will find that they each measure 7/16 in. (11 mm) with no space in inches left over and 1 mm in metric. Thus we can divide it vertically into twelve squares of 7/16 in. Metric: eleven squares of 11 mm and one square of 12 mm. (I've put this extra millimeter in the uppermost square, as you can see in Fig. 121.)

Applying the same measurement of 7/16 in. (11 mm) per space horizontally, you will obtain nine spaces of 7/16 in. (11 mm) and a final space of 3/16 in. (8 mm).

Calculating the proportional enlargement, you obtain a grid of 2 in. (5.1 cm). To understand what is necessary, look

120

at Fig. 121. Of course, this very detailed construction does not correspond to the quick-start method that, as we mentioned earlier (p. 75), Cézanne used when he began a picture. I have nothing against your following Cézanne's technique step by step, you may decide to do just that. But let me remind you that we are here to paint a copy, and we must obtain a faithful reproduction of which we shall later be proud. Our purposes here are probably best met by proceeding thoughtfully and carefully.

Fig. 120. These are the colors Paul Cézanne probably used, and this is the recommended order for placing them on the palette.

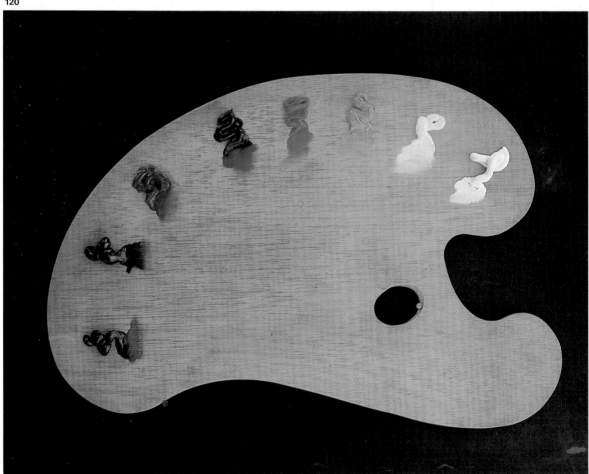

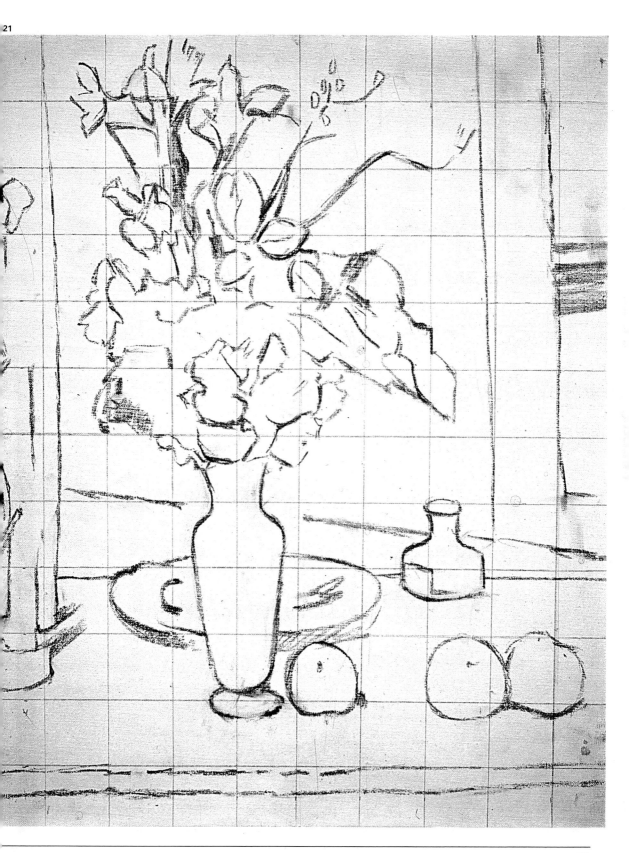

First stage: color choices

Materials:

A round-tipped, soft bristle no. 6 brush; a complete assortment of oils: Titanium white, cadmium yellow, yellow ochre, cadmium red, deep madder, burnt sienna, emerald green, and ultramarine blue deep; turpentine, old newspapers, and rags.

Arrange the colors on the palette in the same order as shown in Fig. 120, and begin your painting, using Fig. 123 as a model. Copy the drawing fairly freely, coloring now and again some of the darker areas. Let yourself be guided by your intuition, by your own feelings, as to when and where color should be applied. For example, look at those patches around the inkwell. The colors used for this area are basically ultramarine blue deep and burnt sienna, mixed with plenty of turpentine to yield a rather liquid consistency. The paint tends toward blue or sienna according to the proportion of colors in the mixture. Even at this early stage, emerald green, deep madder, white, yellow, and ochre have been added to the basic blue and brown to underpin the final diversity and intensity of color in the subject. In Fig. 122 you can see just how the palette looked after this initial stage was completed.

Fig. 122. Observe the colors that appear on the palette before beginning the second stage. Notice the array of dark blue, sienna, and reddish hues with which we have drawn and painted during this first stage.

122

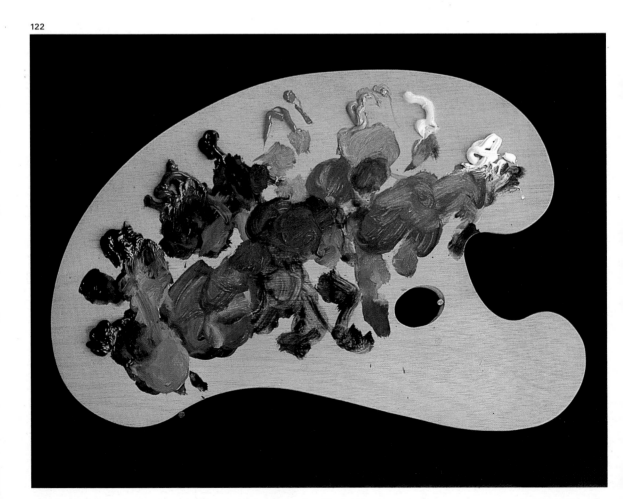

123

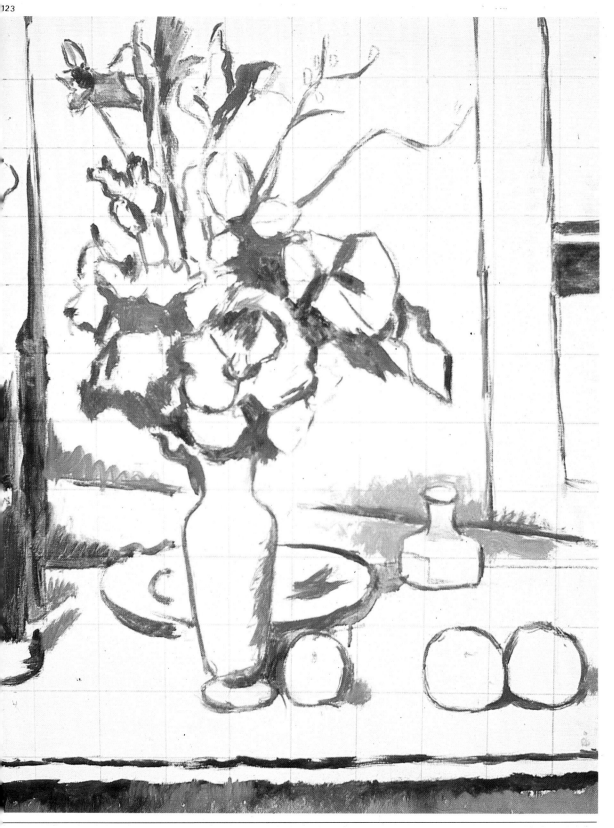

Second stage: direct painting

Materials:
Soft bristle paintbrushes, one round-tipped no. 1, two flat-tipped no. 6, two flat-tipped no. 12, and one flat-tipped no. 14; oil colors; turpentine mixed with a little linseed oil (about 3/4 turps to 1/4 linseed); paper and rags for cleaning the brushes, palette, and so on.

Painting *alla prima*
We are now going to paint in a more or less *alla prima* fashion, which is to say, in one sitting, working wet-in-wet. We will follow the direct painting technique used by Cézanne in this picture. We also intend to follow the artist's lesson of painting overall, without lingering in any one particular spot. We will paint feverishly, with vigor, going all over the place, painting everything at once. I repeat, *everything at once.*

124

1. Flowers, upper parts: white, ultramarine blue, a little deep madder, a little burnt sienna.

2. General outlines: ultramarine and a little burnt sienna mixed with lots of turpentine.

3. Light green of the leaves: emerald green and cadmium yellow.

4. Dark green of the leaves: the previous mixture plus more emerald green and some burnt sienna.

5. Color of the red flowers: cadmium red for the highlights and deep madder with some blue for the shadows.

6. Basic background color: white, ultramarine blue, and a speck of burnt sienna.

7. Basic color of the table: white, ochre, cadmium yellow, and, in certain areas, blue and white.

8. Color of the ripened fruit: the previous mixture with a greater quantity of yellow ochre and the addition of cadmium red.

25

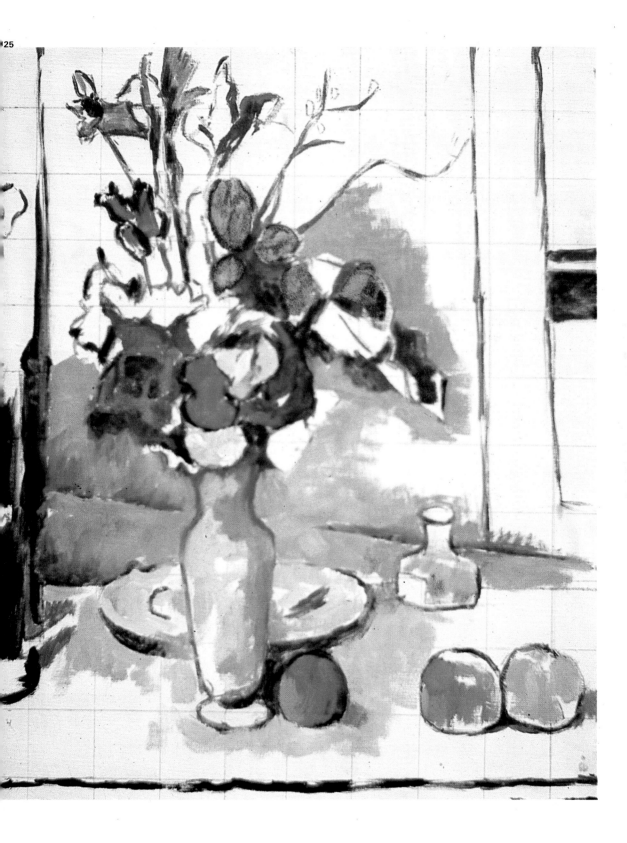

Third stage: refining color

Materials:
Same as those in the previous stage.
The third stage is, in fact, the continuation of the previous one. In practice, you should continue painting *alla prima* just as you have been doing until now, resolving the color, drawing, and shading on the first attempt.

Speaking of shading, don't let yourself fall into the routine of the literal-minded artist who paints a background an area, or even certain shapes in flat, uniform colors with no gradations. Look carefully at the reproduction, observing that Cézanne never painted in a steady fashion. He always used many values and variations of the same basic color. Notice, for example, the illuminated area of the table. Within that general color of light wood, you can see small patches or subtle variations tending toward blue, pink, gold, and gray. And look what happens to the blue background behind the rum bottle. Observe the different nuances of color with which Cézanne painted the inkwell, the fruit, and the vase.

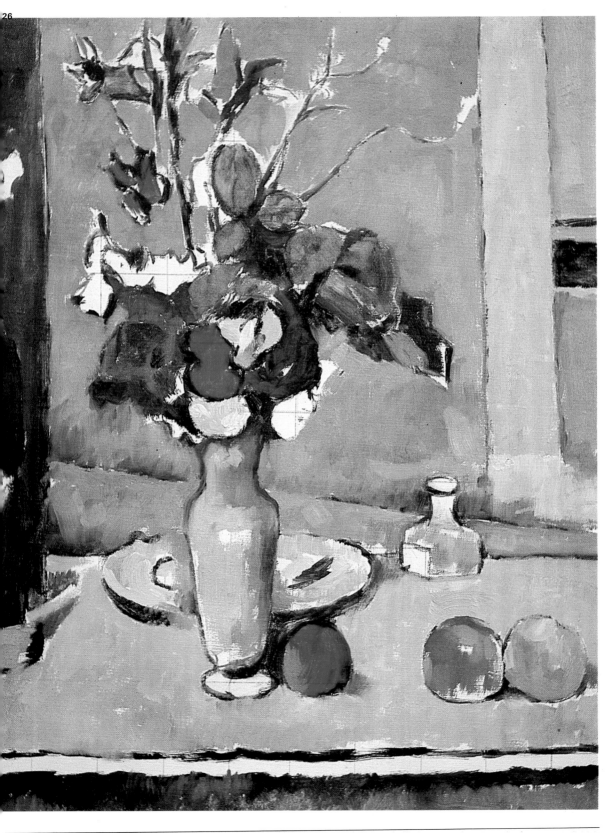

26

Fourth stage: finishing the picture

Materials:
Same as those in the two previous stages. I suggest that once you have finished your first draft of the picture, you allow at least a full day to pass so that you can look at your work with fresh eyes. The important thing is *to correct and to imitate.* In other words, make whatever adjustments are necessary to shapes, colors, and nuances of color to achieve a faithful copy.

Work carefully. Don't overdo it. Don't labor the finishing touches to the point of stifling the fresh, spontaneous quality that you have aimed for up till now. Take a tip from Cézanne: It is preferable to have a less than perfect copy than one that has been tortuously reworked and overdone.

127

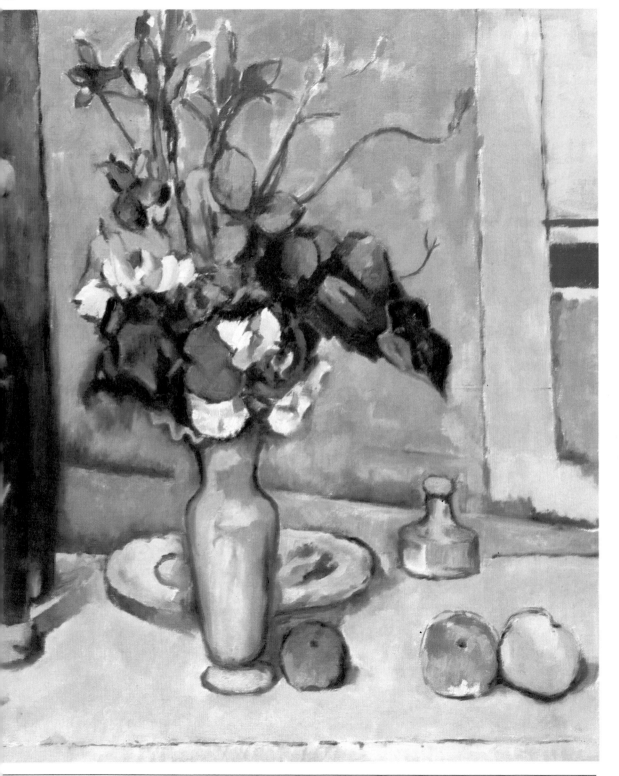

Final tips

Here are some tips that may help you create a better copy:

You can make this or any copy by artificial light, provided that both the picture you are painting and the reproduction receive exactly the same amount and kind of light. Any difference in this respect would mean you are painting either lighter or darker than the reproduction.

If you paint by daylight—which is always advisable—you still need to control and equalize the amount of light both the picture and the reproduction receive. If you have any doubt about the value or intensity of any given color, you can match it more accurately against the reproduction print by dabbing a bit of paint on the edge of a piece of paper or cardboard and holding it next to the print. This will enable you to compare the colors exactly and decide which ones to use.

When there is no more space left on the palette for making up new colors, and you risk painting with dirty or false ones, stop working and clean your palette. It doesn't matter if you lose a specific mixture or color. Mixes are very easy to repeat—your memory has stored them—and fresh mixes will undoubtedly produce colors that are purer and closer to those of the subject. The same must be said with regard to cleaning brushes from time to time. Keep sheets of old newspaper or rags handy, and clean those brushes. Don't forget to do it. You will definitely achieve better results.

Finally, never sign your copy of a painting with the name of the original artist. In the case of *The Blue Vase* there is no signature by Cézanne and thus the problem is eliminated. The fact is this: It is illegal to forge an artist's signature on a copy. You must therefore either sign it yourself (which seems ridiculous to me) or you must leave it without a signature. There is, nevertheless, a middle ground in which you sign with the name of the artist—Pissarro or whoever it may be—adding below, "copy by," and your own name.

And so I've finished.
The experience of copying these works has been both fun and educational. Personally, I've benefited from the Impressionist painters. I now understand Pissarro's colors, mixtures, and technique. I've also experienced and drawn inspiration from Cézanne's painting methods. There have been thrilling moments when I have felt myself transported to other times and places, when I have lived to the utmost the adventure of painting like those great men. I hope and trust that you will experience this same wonderful adventure.

Enjoy painting and the best of luck to you. Goodbye and happy days.